On This Day In

CALIFORNIA
HISTORY

On This Day In

CALIFORNIA
HISTORY

JIM SILVERMAN

THE
History
PRESS

Published by The History Press
Charleston, SC
www.historypress.net

Front cover: all images courtesy Library of Congress.
Back cover, top: courtesy Library of Congress; *middle*: author's collection;
bottom: courtesy Library of Congress.

First published 2017

Manufactured in the United States

ISBN 9781467137133

Library of Congress Control Number: 2017938343

Notice: The information in this book is true and complete to the best of
our knowledge. It is offered without guarantee on the part of the author or
The History Press. The author and The History Press disclaim all liability in
connection with the use of this book.

Contents

Introduction

R eading a one-day-at-a-time calendar of California history is akin to reading J.J. Abrams's script for his television show *Lost*, in which chronology and geography are scrambled. One day's anecdote about a sixteenth-century Spanish explorer discovering San Diego Bay might be followed the next day—and hundreds of years later—by a San Francisco woman patenting an undergarment.

This book is not about history's causes and effects, nor is it a sweeping narrative or an in-depth account of any single event. Instead, you will find bits and pieces of great, curious, tragic and humorous moments—earthquakes, Indians, sports, music, crime, business and government.

Taken together, these bits and pieces are parts of the elusive puzzle called California history.

January

JANUARY 1, 1902: A TRADITION BEGINS

The Rose Parade, an annual event in Pasadena since 1890, was looking for a new way to entertain the crowd when someone suggested a football game. The sport, a novelty in California, would be a change from horse races, ostrich races and the race pitting a camel and an elephant (the elephant won). The contest between the Michigan Wolverines and Stanford Cardinal turned into a blowout. It wasn't just the 49–0 Wolverine victory. Ten thousand people showed up where two thousand were expected. When the game got out of hand, so did the crowd. So began the tradition of college football games on New Year's Day.

JANUARY 2, 1847: BATTLE OF THE MUSTARD STALKS

The only battle of the Mexican-American War fought in today's Silicon Valley was the Battle of Santa Clara, called the "Battle of the Mustard Stalks." It took place near Mission Santa Clara de Asís when U.S. forces went to rescue their men captured while buying or stealing cattle from a ranchero. Locals watched the two-hour fight in a wild mustard field from their rooftops. Four Mexicans and two Americans were injured and four Mexicans killed before a

ceasefire was called. You can visit the Armistice Oak Tree Site, State Historic Landmark No. 260, in Santa Clara's Civic Center Park.

JANUARY 3, 1543: PAINFUL DEMISE

Juan Rodríguez Cabrillo, Portuguese explorer for Spain, died of gangrene and was buried on San Miguel Island, off the Santa Barbara coast. A true conquistador, he conquered Mexico with Hernán Cortés, grew rich on New World gold and became the first European to navigate the California coast; he was probably searching for a shortcut to China, the mythical Strait of Anián. He sailed past San Francisco Bay's foggy mouth, traveling as far north as Point Reyes before turning south. Cabrillo fell, splintering his shin in a battle with Tongva warriors near modern-day Los Angeles. The wound grew infected and led to his demise at age forty-three or forty-four.

JANUARY 4, 1776: OUR LADY OF SORROWS

While patriotic American colonists were fighting for freedom from Great Britain, Juan Bautista de Anza and his expedition to settle Alta California reached Mission San Gabriel near modern-day Los Angeles. They had marched north from Mexico for three months with 240 friars, soldiers and settler families; 695 horses and mules; and 385 bulls and cows. The Spanish king commanded settlements be built to block Russia's territorial expansion south from Alaska, where they hunted furs to sell in China. De Anza's party overshot Monterey Bay and accidentally became the first Europeans to see San Francisco Bay.

JANUARY 5, 1848: GOLD RUSH HIGHLIGHTS

In his message to Congress, President James Polk announced the discovery of gold in California: "The explorations already made warrant the belief that the supply is very large and that gold is found at various places in an extensive district of country." Exactly two years later, the California Exchange opened

in San Francisco. It was a marketplace dealing in raw gold and gold coins, including doubloons, shillings, francs, florins, pesetas, guilders and rupees, plus American eagles and double eagles.

JANUARY 6, 1945: SKUNK AND DEPP

Pepé Le Pew, the cartoon skunk created by Chuck Jones and voiced by Mel Blanc, debuted in "Odor-Able Kitty" for Warner Bros. in Los Angeles. Le Pew inspired Johnny Depp for his role of Captain Jack Sparrow:

> *What I loved about Pepé Le Pew was this guy who was absolutely convinced that he's a great ladies man. And he's a skunk. Watching those cartoons, this guy falls in love, deeply falling in love with this cat. The cat clearly despises him, but Pepé Le Pew takes it as sort of a, "She's just playing hard to get. She's shy. Poor thing." I always loved a character like that, just blinders no matter what the actual reality is happening around him. This guy sees only what he wants to see. Pepé Le Pew was the kind of character who always was able to run between the rain drops. He'd just always make it through.*

JANUARY 7, 1939: TERRORIST OR SCAPEGOAT?

Thomas Joseph "Tom" Mooney, political activist and labor leader, was pardoned and freed after twenty-two years in prison. He was charged and tried three times—but never convicted—of transporting explosives to blow up power transmission lines during a Pacific Gas & Electric strike in 1913. So, nobody was surprised when he was convicted of bombing the July 22, 1916 Preparedness Day Parade in San Francisco honoring the U.S. entry into World War I. The blast killed ten people and wounded forty. Many people suspect that Mooney was scapegoated.

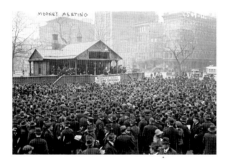

Mass meeting at Union Square in San Francisco to protest the conviction of "Tom" Mooney. Bain News Service (March 9, 1918). *Courtesy Library of Congress.*

JANUARY 8, 1847: DONNER PARTY AGONY

Patrick Breen, traveling with the tragic Donner Party, trapped by deep snow in the Sierra Nevada and starving, wrote in his diary: "Mrs. Reid & company came back this morning; could not find their way on the other side of the Mountain. They have nothing but hides to live on. Martha is to stay here. Milt. & Eliza going to Donners'. Mrs. Reid & the 2 boys going to their own shanty & Virginia. Prospects Dull. May God relieve us all from this difficulty if it is his Holy will. Amen." Nearly half of the Donner Party died en route to California.

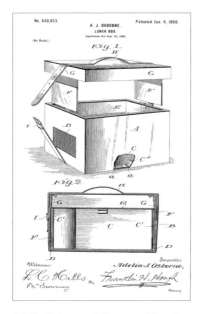

JANUARY 9, 1900: NOVEL LUNCH BOX

Adelia Osborne of Pomona patented a lunch box. "This invention…has for its object the general improvement in this class of devices, the special object of the invention being to provide a compartment lunch-box so constructed as to permit ventilation and the free circulation of air within airspaces surrounding the inner compartments containing the food." This was an early improvement over the basic lunch pail.

Adelia Osborne of Pomona. "Lunch box." U.S patent number 640,933. *Courtesy U.S. Patent and Trademark Office.*

JANUARY 10, 1896:
BYE-BYE, BEACHES

Producers began shipping crude oil from Summerland Oil Field, just off the Santa Barbara coast, the world's first offshore oil field. Summerland turned into a boomtown where housing lots that cost $25 in 1889 sold for $7,500 once the oil wells became productive. Then, seventy-three years later, in

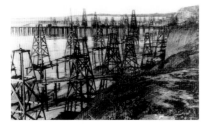

Pumping oil out of the Pacific Ocean at Summerland, California (circa 1920). Courtesy Library of Congress.

1969, a blowout on a drilling platform in the Santa Barbara Channel spilled between eighty thousand and one hundred thousand barrels of oil in ten days, killing around thirty-five hundred sea birds, along with dolphins, elephant seals and sea lions. It was the worst oil spill in California history and led to some of the first environmental protection laws.

JANUARY 11, 1935: "LADY LINDY"

Amelia Earhart taxied her airplane, which she called "old Bessie, the fire horse," down a Honolulu runway, lifting off for Oakland, California, to become the first person to fly solo across the Pacific Ocean. She equaled the fame of Charles Lindbergh (hence her nickname) when she became the first woman to fly solo across the Atlantic in 1932. She leveraged her celebrity into a platform for promoting women's rights in all regards. Then, also famously, she disappeared over the Pacific Ocean while flying solo around the world in 1937.

JANUARY 12, 1910: A WRIGHT RIVAL

Isidore Auguste Marie Louis Paulhan, known as Louis Paulhan, coaxed his biplane to a record height of forty-six hundred feet at the Los Angeles International Air Meet. He and the Wright brothers were rivals in the emerging airplane industry. The Wrights attended the meet—not to compete, but to charge Paulhan with infringing on their patents and prevent him from flying. He flew anyway and won the $19,000 prize.

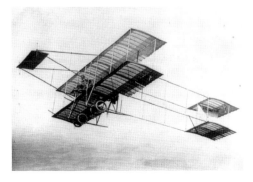

Louis Paulhan making his record flight, flying forty-six hundred feet over Los Angeles, California. Charles C. Pierce & Co., Los Angeles, California (February 2, 1910). *Courtesy Library of Congress.*

JANUARY 13, 1957: FLYIN' CAKE PANS

Wham-O Company, currently headquartered in Emeryville, produced the first Frisbee. The company bought the rights to Fred Morrison's Flyin-Saucer, the world's first toy flying disc, once known as Flyin' Cake Pans, Whirlo-Ways and Pluto Platters, which Morrison sold on the beaches of Santa Monica. Wham-O followed Frisbee's success the next year with the Hula Hoop, then the Slip 'N Slide, Super Ball, Silly String and Hacky Sack.

JANUARY 14, 1967: SUMMER OF LOVE

The Human Be-In in San Francisco marked a milestone in the Summer of Love. It was announced as "A Gathering of the Tribes for a Human Be-In" on the cover of the *San Francisco Oracle*. Some twenty thousand people gathered in Golden Gate Park for a celebration featuring Timothy Leary of "Turn on, tune in, drop out" fame; Ram Dass, the spiritual leader; poets Allen Ginsberg and Gary Snyder; and music by the Grateful Dead, Jefferson Airplane and other local psychedelic bands. LSD-laced "White Lightning" was the refreshment du jour.

JANUARY 15, 1816: FIRST YANK IN CALI

Thomas Doak became the first U.S. citizen to settle in Alta California. He had been aboard an American schooner that anchored near Santa Barbara to trade with a local rancho, which was against Spanish law. Doak either deserted or was caught smuggling, chose to stay, converted to Catholicism, was baptized Felípe Santiago and married into a rancho family. He then worked with Costanoan people living at Mission San Juan Bautista called neophytes to decorate its chapel, which looks today as it did then.

JANUARY 16, 1850: GOLD RUSH SHOWTIME

John Atwater presented *The Wife* at Washington Hall, San Francisco's first theater. According to the *San Francisco Call*, "The only thing worthy of note on that occasion was the high price charged for admission, the large attendance and the poor performance." The city developed into such a theatrical hub that on January 16, 1865, teenage brothers Charles and Michael H. de Young launched the *Daily Dramatic Chronicle* as "a daily record of affairs— local, critical and theatrical." Today, the *Chronicle* is the Bay Area's leading newspaper.

JANUARY 17, 1849: GOLD RUSH TICKETS

The SS *California*, a side-wheeler steamship, departed New York for San Francisco before the news of gold in California had reached the East Coast. The ship carried mail, freight and mostly empty berths. But by the time it rounded Cape Horn and anchored in Valparaíso, Chile, gold fever had spread and one hundred men clamored for tickets. When it reached Panama on January 17, so many men wanted passage that tickets sold for upward of $200. When the California finally anchored in San Francisco Bay, its crew abandoned it for the gold fields; it took the *California*'s captain two months to find new sailors and sail away.

JANUARY 18, 1911: TAILHOOK

Eugene Burton Ely made aviation history when he took off from the Tanforan Racetrack in San Bruno and landed on the deck of the USS *Pennsylvania* in San Francisco Bay. That was the first time an aircraft landed on a ship and the first time a tailhook system was used. Afterward, Ely announced, "It was easy enough. I think the trick could be successfully turned nine times out of ten." Aviation history was made again on January 18, 1957, when three B-52s landed at March Air Force Base, between Riverside and Moreno Valley. They completed the first nonstop, round-the-world flight by jet planes, airborne for some forty-five hours.

JANUARY 19, 1983: LISA

Apple Computer, in Mountain View, announced the Apple Lisa. The name was an acronym for Local Integrated Software Architecture. It was the first commercial personal computer with a graphical user interface and a mouse and was more advanced than the contemporary Macintosh. Lisa originally cost $9,995. Although a commercial failure, it held its value over time; one was sold to a collector for $15,000 in 2010.

JANUARY 20, 1968: GAME OF THE CENTURY

In what was promoted as the "Game of the Century," the Houston Cougars ended the UCLA Bruins' forty-seven-game, two-and-a-half-season winning streak with a 71–69 victory. It was unlike any other regular season basketball game. The buildup was enormous. UCLA dominated college basketball, being NCAA champs in 1964, 1965 and 1967. The game made the cover of *Sports Illustrated* and drew a huge television audience, proving the value of NCAA basketball in the national primetime market, leading to what became March Madness. The next year, in 1969, NBC paid $500,000 to broadcast the NCAA championship game. In 2008, it paid $545 million for the full tournament.

JANUARY 21, 1966: HIPPIE HISTORY

The Trips Festival, the ultimate acid test, was a LSD-laced gathering marking the dawn of San Francisco's Haight-Ashbury hippie era. LSD was then legal. Ten thousand people came together for a three-day party at Longshoreman's Hall. It was the brainchild of Steward Brand, of Whole Earth Catalog fame, with help from the Merry Pranksters. Bill Graham, later a legendary concert producer, brought the newly formed Grateful Dead to play, along with Big Brother and the Holding Company and Jefferson Airplane. The festival's sound engineering was unprecedented, showcasing one of the first light shows. The wellspring for Woodstock and Burning Man was so historic that the California Historical Society celebrated its fiftieth anniversary.

JANUARY 22, 1949: CALLING CHINATOWN

The Chinatown Telephone Exchange in San Francisco closed after sixty-two years in business. It was challenging to work there, because people calling the exchange often asked for the person they wanted to speak with by name rather than by telephone number—it was considered rude to ask for someone by number. So, operators had to know everyone by name, as well as everyone's address and occupation so as to not confuse people with identical names. Operators had to speak five Chinese dialects as well as English. Bank of Canton bought and restored the Chinatown Telephone Exchange in 1960. It can be visited at 743 Washington Street today.

JANUARY 23, 1900: A NOVEL SHIPPING BOX

Arlanda McCandless of Los Angeles patented a shipping box.

> *This invention relates to boxes for shipping fruit and berries and other easily-perishable articles; and the object of the invention is to provide a simple and inexpensive device of the character set forth which can be supplied to a consumer in large lots in collapsed or blank form, to be assembled by him for use as occasion may require, and the construction is such that the contents of the boxes can be so ventilated as to maintain the same in a fresh condition during shipment.*

Successfully shipping perishable fruit to markets around the country was key to the success of this giant Southern California industry.

JANUARY 24, 1848: SPARKING THE GOLD RUSH

While working to build a lumber mill for John Sutter, James Marshall spotted the glittering flakes that ignited the Gold Rush. He reportedly said, "I have found it." Marshall went on: "'What is it?' inquired a workman named Scott. 'Gold,' I answered. 'Oh! no,' replied Scott. 'That can't be.' I said, 'I know it to be nothing else.'" He tested his find against a gold coin, then pounded some flakes on an anvil to see if they were soft

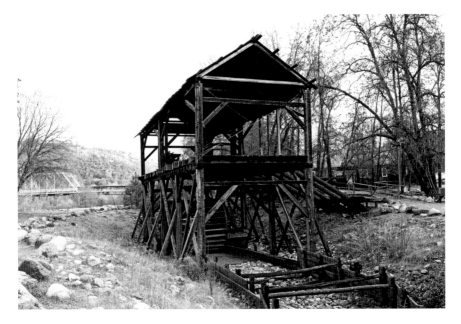

The tailrace, or structure conveying water away from a mill, at the remains of Sutter's Mill in Coloma, where the Gold Rush began, on the south fork of the American River in El Dorado County, California. Photograph by Carol Highsmith (2012). *Courtesy Library of Congress.*

and malleable. He asked Jennie Wimmer, the camp cook, to test the flakes in her kettle where she was making lye soap. The results were positive.

JANUARY 25, 1949: AN EMMY FOR OSCAR

The first Emmy Awards, TV's promotional response to the Oscars, was presented at the Hollywood Athletic Club. At first, the award recognized only shows produced and aired in the Los Angeles area, where there were some 350 television sets. KTLA swept the awards with *Armchair Detective*, which was something like a mashup of *The Westinghouse-Desilu Playhouse* and *America's Most Wanted*. The award was initially called "Immy," a nickname for the image orthicon tube in early cameras. The name was then feminized to "Emmy" to flatter the statuette and match the Oscar.

JANUARY 26, 1929: LGBT HISTORY

Frances Orlando, age nineteen, was arrested in San Francisco for dressing in men's clothing. Later known as Richard Orlando, a film studio carpenter, he married eighteen-year-old Elizabeth Nunes. She claimed not to know her husband's gender until five weeks after their marriage, when Orlando was arrested on unspecified charges, as reported on October 9, 1941. Orlando dressed as a man for fourteen years because, he said, "Well, it was a lot easier to find jobs. I was eating when a lot of girls I know were going hungry."

JANUARY 27, 2010: IPAD LAUNCH

Steve Jobs introduced Apple's iPad at MacWorld in San Francisco, bridging the gap between smartphones and laptops. On the day it was released in April, three hundred thousand units were sold; one million were sold in twenty-eight days. Apple sold fifteen million units that year and captured 75 percent of the market by December. With an App Store providing 350,000 apps, some 65,000 of which were designed specifically for it, the iPad had invented and controlled a new category of consumer electronics. Jobs called it "a magical and revolutionary device at an unbelievable price." He was right.

JANUARY 28, 1969: MAJOR BLOWOUT

A blown-out drilling rig off the Santa Barbara coast created the largest oil spill in the United States to date. It's still the third largest in the nation's history. The explosion tore through the ocean floor, causing oil to bubble up all around the Union Oil platform. Within twenty-four hours, seventy-five square miles of ocean were black with oil, six inches deep in some places—so thick that there was danger of a massive fire. Media coverage and the volunteer response were intense. The environmental damage was unprecedented; as a result, some of the first modern environmental protection laws were passed. Exactly seventeen years later, on January 28, 1986, a tank barge lost a hatch cover while being towed from Martinez to Long Beach and spilled around 25,800 gallons of crude oil, killing some 6,500 seabirds.

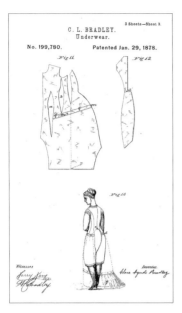

C. L. BRADLEY.
Underwear.
No. 199,780. 3 Sheets—Sheet 3.
Patented Jan. 29, 1878.

Clara L. Bradley of San Francisco. "Underwear." U.S. patent number 199,780. *Courtesy U.S. Patent and Trademark Office.*

JANUARY 29, 1878: NOVEL UNDERWEAR

Clara L. Bradley of San Francisco patented a piece of ladies underwear: "As by this improvement only one skirt is necessary, and this one possesses all the advantages of the several skirts now generally worn, and also to furnish a skirt which is peculiarly adapted to the present style of close-fitting garments." This appears to be a modern step away from the corsets and bustles that defined Victorian women's fashion.

JANUARY 30, 1982: AN ORIGINAL VIRUS

Richard Skrenta, a fifteen-year-old student at Mount Lebanon High School in Pennsylvania, wrote the first PC virus code and then disguised it as an Apple boot program called "Elk Cloner" installed on a game disc. The prank caused no damage, but it planted a malevolent seed from which others would grow. Users knew they were infected when the following appeared on their monitor:

> *Elk Cloner: The program with a personality*
> *It will get on all your disks*
> *It will infiltrate your chips*
> *Yes, it's Cloner!*
> *It will stick to you like glue*
> *It will modify RAM too*
> *Send in the Cloner!*

Today, Richard Skrenta is a computer programmer and Silicon Valley serial entrepreneur.

JANUARY 31, 1851: GOLD RUSH ORPHANS

San Francisco Orphan's Asylum was founded, the first in California, in an effort to help siblings whose parents died from cholera on their way to the Gold Rush. Most children in the city at that time lived with a single parent. By 1852, there were twenty-six children living at the asylum, which eventually became home to some three hundred. The two-story Gothic stone structure stood on two city blocks in Hayes Valley, bought for $100. In old photographs, the building looks gloomy, but it was a friendly place that welcomed neighborhood children to play in the garden.

February

FEBRUARY 1, 1961: WHERE PRESIDENTS PLAY

A U.S. post office opened in Rancho Mirage in the Coachella Valley, the Riverside County community near Palm Desert that grew into a Hollywood movie-star vacation destination in the 1930s. It's also the address of Sunnylands, Walter and Leonore Annenberg's art-filled estate built in the 1960s where the power couple—media mogul, diplomat and philanthropists—hosted Frank Sinatra, Bob Hope, Fred Astaire, Ginger Rogers, British royalty and eight U.S. presidents at their home with a private golf course. Today, Rancho Mirage attracts golfers, gamblers and people heading to the Betty Ford Center for recovery from chemical dependency.

FEBRUARY 2, 1812: RUSSIAN FORT

Russian colonists founded what's now called Fort Ross on the Sonoma coast as a southern agricultural settlement to support their fur-hunting colonies in Alaska. They built the first windmills and ships in Alta California, used glass windows and stoves in their houses, planted the first vineyards north of San Francisco and introduced Gravenstein apple trees to the region, still a cherished local variety. The outpost closed in 1841 due to smallpox and

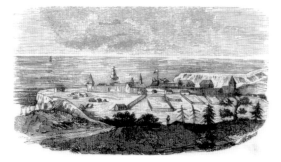

Engraving of Fort Ross from *Veduta di Ross stabilimento Russo vicino alla Bodega* from *Viaggio Intorno Globo Principalmente California Isole* by Auguste Bernard Duhaut-Cilly (1841). *Courtesy Library of Congress.*

changed political winds. John Sutter bought them out to outfit his fort. You can visit Fort Ross and Sutter's Fort, now California State Historic Parks and hosts to living history programs.

FEBRUARY 3, 1847: DONNER PARTY RESCUE

Washington Bartlett, the alcalde (mayor) of San Francisco, called a meeting to raise funds and organize a team to rescue the Donner Party, starving and snowbound in the Sierra Nevada. James Reed had sounded the alarm when he reached Sutter's Fort ahead of the others, having been expelled from the wagon train in October for killing a man who infuriated him by beating an animal. Reed knew his wife and children were trapped and starving along with the rest of the Donner Party.

FEBRUARY 4, 1851: PLAY BALL!

The first West Coast baseball game was played in San Francisco. According to a newspaper report, it was held at Portsmouth Square, then the center of town and now a park in Chinatown. A later account credits sandlot baseball

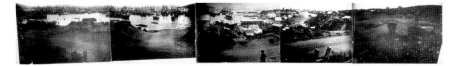

San Francisco from the Rincon Hill Sand Dunes above Happy Valley. A five-panel, 5.5- by 36-inch photograph. Copyright Martin Behrman (1851). *Courtesy Library of Congress.*

starting in the 1860s somewhere around today's Civic Center. A third account claims that the first team was organized in Dan's Oyster Saloon on Montgomery Street, in today's Financial District. They elected officers and met regularly to drink "but never did get around to playing a game." Anita Day Hubbard, *Call Bulletin* reporter, said the first game between the Eagles and the Red Rovers tied at thirty-three runs after nine innings and ended with a brawl.

FEBRUARY 5, 1919: UA

The biggest Hollywood movie stars of their day—D.W. Griffith, Charlie Chaplin, Mary Pickford and Douglas Fairbanks—formed United Artists. It was a radical move for artistic and financial freedom, a rebellion against commercial studios that kept talent on a short leash. They planned to make movies, collectively distribute their films and then share the profit. It sounded good, but arguments between Chaplin, who kept some films away from UA, and Pickford, "America's Sweetheart," who had the best business mind, nearly undid the agreement. They managed to reconcile, proved their business model and dominated the movie industry through the 1930s.

FEBRUARY 6, 1912: IMPERIAL LIBRARY

Imperial County Free Library, California's sixteenth, was founded. It had no funds for material until September, so the California State Library loaned it 885 books to initiate service in El Centro, Brawley, Calexico and Holtville. The state library previously sent a traveling collection to El Centro as early as 1905. It was housed in the town's first business building, a combination hardware store and post office. At one time, the collection was shelved at the jail on Fifth Street, opposite Holt Opera House. Today, Imperial County Free Library encourages parents to read 1,000 books to their children before they begin kindergarten.

FEBRUARY 7, 1914: LITTLE TRAMP

Charlie Chaplin introduced his Little Tramp character in *Kid Auto Races at Venice*, a short film recorded in Santa Monica. He played a spectator at the Junior Vanderbilt Cup, an actual junior version of America's first major car race. Chaplin improvised gags in the middle of the race, upsetting clueless racers and spectators. It was the start of Chaplin's busy year, in which he produced and starred in thirty short films.

FEBRUARY 8, 2001: CALIFORNIA ADVENTURE

Disney's California Adventure Park opened as a new history-themed attraction adjoining Disneyland in Anaheim. It was designed to appeal primarily to adults. The park turned out to be a bust, so it was reimagined with rides for kids, expanded and rebuilt at nearly twice the original construction cost. The new, rebranded Disney California Adventure formula paid off. Some 8.7 million people visited in 2014, making it the tenth-most-visited theme park in the world that year.

FEBRUARY 9, 1971: BIG EARTHQUAKE

The San Fernando earthquake, also known as the Sylmar earthquake, struck north of Los Angeles, lasting about twelve seconds. The temblor measuring 6.6 on the Richter scale killed sixty-four people, injured some two thousand and caused around $550 million in damages. Hospitals collapsed, freeway overpasses pancaked and power stations toppled, sparking fires. At Olive View Hospital in Sylmar, built to new seismic safety standards, the building's wings separated from the main structure and stair towers fell. Thousands of residents downstream from the Lower Van Norman Dam evacuated. Local school buildings, built to higher construction standards following the 1933 Long Beach earthquake, were relatively unaffected.

FEBRUARY 10, 1961: CHARGERS

The Chargers moved to San Diego after their premier season in Los Angeles. Founded as a charter American Football League team, along with the Denver Broncos, Dallas Texans, Oakland Raiders, New York Titans, Houston Oilers, Buffalo Bills and Boston Patriots, the Chargers dominated their AFC division for five of the league's first six years, demolishing the Patriots, 51–10, to capture the title in 1963. The team shifted to the National Football League as part of a merger and has been to the playoffs thirteen times and the Super Bowl once since 1970. People wondered if they would remain in San Diego or return to Los Angeles. LA won the toss.

FEBRUARY 11, 1933: DEATH VALLEY

When Death Valley Monument was dedicated, it would have to wait sixty-one years to become a national park. Now it's the largest park in the lower forty-eight states and includes the second-lowest spot in the Western Hemisphere, 282 feet below sea level—and just 84.6 miles from the highest spot in the lower forty-eight states, Mount Whitney (elevation 14,505 feet). One of the hottest temperatures on earth was recorded in Death Valley, 134 degrees Fahrenheit, in 1913. Although a party of forty-niners who became lost in the desert on their way to the Gold Rush named it Death Valley, Panamint Shoshone people called it home for more than one thousand years.

FEBRUARY 12, 2004: MORE LGBT HISTORY

Gavin Newsom, newly elected San Francisco mayor, instructed city clerks to issue marriage licenses to same-sex couples. It was a bold action, inspired by same-sex marriages in Massachusetts and his response to support for a rumored U.S. constitutional amendment defining marriage as between a man and a woman. The LGBT community acted quickly. Some four thousand couples married before the California Supreme Court ended the practice on March 11, voiding those licenses already granted. A monumental battle followed in the courts and voting booths, culminating

in the California Supreme Court affirming the constitutional right of same-sex couples to marry.

FEBRUARY 13, 1877: MORE NOVEL UNDERWEAR

Coelia Curtis, of San Francisco, patented an improved undergarment. "My invention relates to the mode of cutting and forming that class of undergarments for female wear in which the waist and drawers form a single garment." One wonders if she and Clara L. Bradley were friends. Both San Francisco residents patented ladies' undergarments.

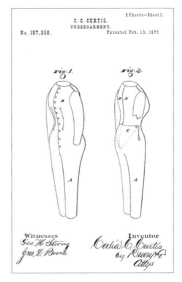

Coelia Curtis of San Francisco. "Undergarment." U.S. patent number 187,358. *Courtesy U.S. Patent and Trademark Office.*

FEBRUARY 14, 1872: WILDLIFE SANCTUARY

Lake Merritt, downtown Oakland's large tidal lagoon ringed by parks, was dedicated as California's first bird refuge. Dr. Samuel Merritt, Oakland mayor, took steps in that direction by donating 155 acres of tidal land in 1869. He proposed it as the first National Wildlife Refuge, ending its use as a sewage pond and duck-hunting ground. Merritt's efforts paid off. Today, the lake named in his honor is home to some 140 species of birds, 30 species of fish, crustaceans, bivalves and other invertebrates. Opossums, feral cats and fox squirrels live in the park, where turkey and deer are sometimes seen, along with abandoned pets, including even a python.

FEBRUARY 15, 1769: PORTOLÀ EXPEDITION

Gaspar de Portolà's ship *San Antonio* set sail from La Paz, Mexico, heading north for the Alta California coast as part of the Spanish king's plan to establish religious and military outposts to blunt other nations' territorial

ambitions, especially Great Britain and Russia. Portolà coordinated a two-pronged expedition by land and sea. The *San Carlos* set sail in January, the *San Antonio* in February. A column of padres, soldiers and settlers marched north in March. After they rendezvoused at San Diego Bay, Portolà and his men marched north to Monterey Bay but overshot his goal, becoming the first Europeans to see San Francisco Bay.

FEBRUARY 16, 1857: BED BUG

Founded as a gold rush supply town, this small Sierra foothills community was once called Bed Bug, Freeze Out, Hardscrabble, Woosterville, Jone City, Jone Valley and Rickeyville before finally settling, for reasons that are disputed, on the name "Ione City."

FEBRUARY 17, 1911: A WRIGHT RIVAL

Glenn Hammond Curtiss, aviation pioneer and one of the fathers of the U.S. aircraft industry, flew the first hydroplane to and from a ship in San Diego Bay. He challenged the Wrights for patents and prizes in the early years of aviation, designed new planes and won competitions in Europe and across America in the 1910s. He understood military air power and demonstrated a simulated bombing to naval officers in New York before setting up a training facility in San Diego to teach army and naval personnel. Curtiss captured the popular imagination to the degree that Tom Swift, hero of novels like *Tom Swift and His Airship* (1910), was probably inspired by him.

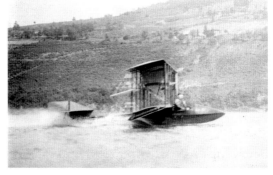

Curtiss "Flying boat" on the surface of Lake Keuka, New York. Bain News Service (1912). *Courtesy Library of Congress.*

FEBRUARY 18, 1939: WORLD'S FAIR

The Golden Gate International Exposition opened on San Francisco's Treasure Island. In the midst of the Great Depression, it celebrated construction of the Oakland Bay Bridge (1936) and Golden Gate Bridge (1937). It was a world's fair built on an artificial Treasure Island just off the city's coast to showcase Pacific Rim cultures in an art deco architectural setting. "The Magic City," as it was called, was experienced best at night, when the colored spotlights that lit the sky could be seen from miles around. The exposition didn't last long but offered just what the city needed: jobs, success against long odds and a magical experience.

FEBRUARY 19, 1878: NOVEL APIARY

Emma Carter of Folsom City patented an improved bee-feeding device. "My improved bee-feeding device, as will be readily seen, is simple, clean, and easy of access." Beekeeping had become a major industry in California. Russian colonists introduced hives to the Sonoma coast in the 1830s. Botanist Christopher Shelton landed in San Francisco on March 14, 1853, with 12 colonies. But it was John Harbison who built the beekeeping business on the West Coast, arriving in San Diego with 110 colonies on November 28, 1869. By the mid-1870s, he had made California the nation's leading honey producer, which it remains. Nevertheless, Emma Carter claimed that her device was an improvement.

FEBRUARY 20, 1902: ANSEL ADAMS

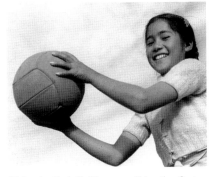

Ansel Adams, landscape photographer whose black-and-white images helped expand the National Park system, was born at home in San Francisco near the Golden Gate before the bridge was built. His lifelong love of Yosemite National Park began with a family trip in 1916. Three years later,

Girl and volleyball, Manzanar Relocation Center, California. Photograph by Ansel Adams (1943). *Courtesy Library of Congress.*

he joined the Sierra Club, then spent several summers caring for the organization's headquarters in Yosemite Valley, later the focus of his books: *Sierra Nevada: The John Muir Trail* (1938), *Illustrated Guide to Yosemite Valley* (1940), *Yosemite and the High Sierra* (1948) and *My Camera in Yosemite Valley* (1949). He and Dorothea Lange also documented the Japanese American internment.

FEBRUARY 21, 1937: FLYING CAR

Waldo Waterman flew his Arrowbile, landed, detached its wing and then drove down the road. It was one of the first successful flying cars. The San Diego inventor, inspired by aviation pioneers in the region, began experimenting with flight as a teenager and ostensibly designed his dream machine for everyone. It improved on his earlier monoplane, the Whatsit, and was powered by a Studebaker engine. That car company expressed interest in producing Waterman's flying car until the Great Depression intervened. Just five Arrowbiles were built; a later version is on display at the Smithsonian National Air and Space Museum.

FEBRUARY 22, 1906: AZUSA STREET REVIVAL

William Seymour, an African American charismatic evangelist, arrived in Los Angeles. In April, he launched the historic Azusa Street Revival, racially diverse meetings appealing to all ages, genders and social classes and igniting the Pentecostal movement. Seymour spoke in tongues and channeled the Spirit through others at ecstatic services held frequently and spontaneously at all hours. Despite schisms over race and other issues, today, the Pentecostal community of five hundred million believers is among the fastest-growing forms of Christianity.

FEBRUARY 23, 1942: JAPANESE SUB ATTACKS

A Japanese submarine bombed the Ellwood Oil Field near Santa Barbara. It inflamed panic following the attack on Pearl Harbor in December, people

imagining it as the prelude to a West Coast invasion. The next night, in what newspapers called the "Battle of Los Angeles," coastal defenses fired antiaircraft guns for hours against never-confirmed sightings of enemy aircraft. Japanese Americans were unjustly accused of complicity with the enemy; soon afterward, President Roosevelt ordered the internment of some 110,000 people for years during the war.

FEBRUARY 24, 1921: FLYING RUMRUNNER

The Cloudster, a gigantic biplane built by Donald Douglas in Los Angeles to fly coast to coast, became the first aircraft to fly with a load heavier than its own weight. It broke the Pacific coast altitude record by climbing to 19,160 feet. However, when it failed a transcontinental attempt, the giant biplane was sold, then retrofitted for sightseeing with two open cockpits and five passenger seats in a cabin. Later it was modified to become one of the first airliners ferrying passengers from San Diego to Los Angeles. During Prohibition, it ran whiskey up from Mexico.

FEBRUARY 25, 1854: MOVEABLE CAPITAL

Sacramento became California's state capital. The state government was first seated in San Jose (1849) before moving to Vallejo (1852) and Benicia (1853). After moving to Sacramento and then San Francisco (1862), Sacramento finally became the capital's permanent home (1869).

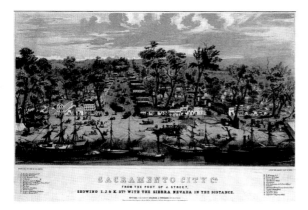

Sacramento City. Illustration by Joseph Britton. Lithographed and published by Cooke & LeCount, San Francisco, California (1852). *Courtesy Library of Congress.*

FEBRUARY 26, 1884: PASADENA LIBRARY

Pasadena Public Library opened in a building on Central School grounds on Colorado Street between Raymond Street and the Santa Fe Railroad tracks. When land prices soared, the library sold for $10,000.00 the lot it had bought for $170.00 and moved its building. Before that, starting in 1882, readers could subscribe to the Pasadena Library and Village Improvement Society. The library charged $0.25 per month for borrowing privileges and raised funds by selling $5.00 stock certificates and hosting citrus fairs.

FEBRUARY 27, 2009: DROUGHT

Governor Arnold Schwarzenegger declared a statewide drought emergency. He said, "This is a crisis, just as severe as an earthquake or raging wildfire." Scientists measured soil moisture to determine that the years from 2011 to 2014 were the driest in some twelve hundred years. Less rain fell in 2013 than during any year since the Gold Rush. Tree-ring studies indicated that droughts commonly last ten years and longer. It appears that the twentieth century was one of the wettest periods in the last seven thousand years.

FEBRUARY 28, 1966: GREAT HOLDOUT

Sandy Koufax and Don Drysdale, two of the greatest, most popular pitchers in baseball history, refused to renew contracts with the Los Angeles Dodgers. Together, the stars had won two hundred games over five seasons, and their unprecedented thirty-two-day holdout would change the relationship between players and owners. The sticking point was a clause binding a player to a team until he was traded or released. They threatened to leave baseball for movie roles. "Ballplayers aren't slaves," Koufax told reporters, "and we have a right to negotiate." The reserve clause was abolished in 1975.

FEBRUARY 29, 1940: BLOCKBUSTER HIT

Gone with the Wind, the epic Civil War romance based on Margaret Mitchell's best-selling book, was nominated for thirteen Academy Awards and won ten, a record at the time. Advance publicity was so enormous that some three hundred thousand people lined the streets of Atlanta to watch limousines drive the movie stars arriving at the airport to the premier. Hattie McDaniel, who won an Oscar for Best Support Actress, the first African American actor to win one, was excluded from the premier due to racial segregation laws. At the awards ceremony in Los Angeles, she had to sit at a separate table at the back of the room, away from her costars.

March

MARCH 1, 1984: CHILD STAR

Jackie Coogan, the Los Angeles–born actor famous as a child star during the silent movie era, died in Santa Monica at age sixty-nine. More recently, he had played Uncle Fester in *The Addams Family*, a 1960s sitcom. Lawyers identify him with the Coogan Act—not a performance—which safeguards the earnings of child actors until they become adults. Coogan's parents had spent most of the money he earned as a kid.

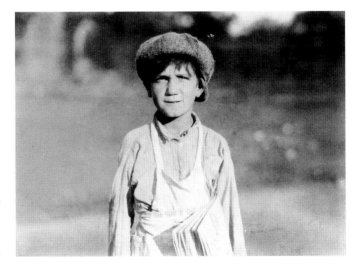

Jackie Coogan, newsboy. Photograph by Lewis Wickes Hine in Hartford, Connecticut (August 26, 1924). *Courtesy Library of Congress.*

MARCH 2, 1987: COLOR MAC

The Macintosh II computer, not to be confused with the Apple II, made its debut. Steve Jobs didn't like its expansion slots and color monitor, so Apple developers hid the Macintosh II behind code names like Little Big Mac, Milwaukee, Ikki, Cabernet, Reno, Becks, Paris and Uzi. Development was fast-tracked after Jobs was fired. Its color monitor set a new standard. Although not fast, it was the first Macintosh that let owners open the lid without voiding the warranty. It also introduced the "Chimes of Death" to accompany the "Sad Mac" logo when the hardware crashed.

MARCH 3, 1855: CAMEL CORPS

After the Gold Rush, the U.S. Congress knew it needed to improve transportation between California and the Mississippi River. On March 3, 1855, it budgeted $30,000 for a Camel Corps to carry goods across the desert to California. At one time, the U.S. Army managed a herd of seventy camels. The animals had impressive endurance, but they did not get along with the horses. Then came the Civil War, and the camels were sold off, but not before camel barns were built in Benicia, which you can visit today.

MARCH 4, 1928: BUNION DERBY

The Trans-American Footrace, nicknamed the "Bunion Derby," took off from Legion Ascot Speedway in Los Angeles, a 3,423.5-mile course ending at Madison Square Garden in New York City. Nearly a quarter of the 199 people who started crossed the finish line eighty-four days later. Andy Payne, a twenty-year-old Oklahoma Cherokee, crossed first. "I just thought I could do it," he said when he won the $25,000 prize. Harry Abrams ran the race again the next year, making him the first and maybe only person to run a footrace across the United States twice.

MARCH 5, 1975: GEEK CLUB

Homebrew Computer Club, a bunch of computer geeks, initially met at Gordon French's garage in Menlo Park, excited to see the first MITS Altair microcomputer sent by People's Computer Company for their review. Founders of Apple Inc. were there, along with other would-be computer entrepreneurs and hackers. Steve Wozniak said that this meeting inspired his Apple I design. Members swapped parts, shared digital dreams and met at various sites for around eighteen months. They formed the nucleus of the personal computer revolution.

MARCH 6, 1910: DANCE 'TIL YOU DROP

A dance marathon at Puckett's Cotillion Hall in San Francisco ended when six couples broke a record by dancing for fourteen hours and forty-one minutes. Dance marathons, sometimes called walkathons, were popular entertainment in the 1920s and '30s. Endurance dancers could win monetary prizes and a moment of fame. Rules varied; usually, one partner could fall asleep as long as the other partner held them up and kept dancing. One contestant danced for eighty-seven hours, collapsed and died on the dance floor. People paid to be in the audience.

MARCH 7, 1847: STARVED CAMP

A blizzard struck the Sierra Nevada for three days, trapping rescue teams and Donner Party survivors, who huddled around a fire, struggling to keep it burning with nothing to eat for two days. Five-year-old Isaac Donner died. Most were too weak to move after the storm passed. James Reed and the rescuers took three children and headed down the mountain. Thirteen people stayed behind with some firewood, seeds, a little tea, coffee and a lump of sugar. It was five days before more help arrived. In the meantime, three people died and were cannibalized at what became known as "Starved Camp."

MARCH 8, 1870: INVENTIVE ORE ROASTING

Elizabeth A. Burns of Meadow Lake patented an improvement to roasting ores. "My invention relates to an improved method and process of treating rocks, and more especially ores and sulphurets which contain the precious metals, for the purpose of desulphurizing and disintegrating them, in order to render them capable of being easily separated, and to render the metals contained in them capable of amalgamation and extraction." Eliza Hall of San Francisco patented an ore-smelting furnace in 1864.

MARCH 9, 1959: BARBIE'S DEBUT

Barbie, the doll Ruth Handler designed, inspired by her daughter's interest in all things teenaged, changed the toy world. Mattel, from El Segundo, introduced her at the American International Toy Fair in New York. Not only was Barbie the first mass-produced toy doll in the United States with adult features, she was initially available with a blonde or brunette ponytail. By the time Barbie turned fifty years old in 2009, she had become iconic, with sales exceeding one billion units.

MARCH 10, 1933: LONG BEACH TEMBLOR

At nearly 6:00 p.m., an earthquake measuring 6.4 on the Richter scale struck just off the Long Beach shore. In less than ten seconds, 115 people were dead and some $40 million in property damage done. Falling debris killed people as they rushed outside. Nearly every building in a three-block section of Compton was flattened, and more than 230 school buildings were wrecked or damaged. Had the earthquake struck during school hours, the death toll would have been much higher, a fact the California state legislature recognized when it passed laws just one month later mandating that school buildings be earthquake safe.

MARCH 11, 1918: TREE HUGGERS

Save the Redwoods League began in the early years of the environmental movement. It argued that opening the Redwood Highway called for protecting ancient redwood forests from logging and tourism. After all, the tallest tree on earth is a redwood that is equivalent to a thirty-seven-story building. They can live for 2,000 years and have lived on our planet for some 240 million years. Only about 5 percent of the ancient forests still stand.

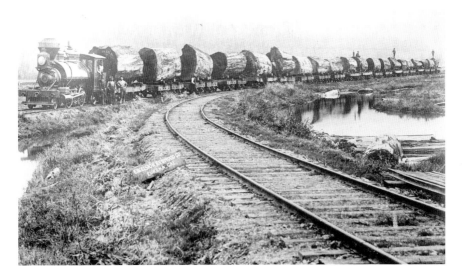

Redwood logs on the way from forest to mill. Circa 1915. *Courtesy Library of Congress.*

MARCH 12, 1911: HUMAN TRAFFICKERS

Immigration officials rescued six Chinese slave girls in San Francisco. They were reportedly purchased for $25,000. California has a long, ugly history of trafficking in Chinese women. Between 1852 and 1873, one Chinese tong, an organized criminal syndicate, imported some six thousand enslaved women. Following the Chinese Exclusion Act in 1882, traffickers bribed immigration officials, although not always successfully. Today, San Francisco remains a human trafficking hub, especially for child sex trafficking. A 2014 task force identified 291 known or suspected survivors in six months.

MARCH 13, 1928: CATACLYSMIC COLLAPSE

The St. Francis Dam collapse, east of Los Angeles, was one of the most devastating disasters in California. Built in 1913 to solve the city's perpetual water shortage by storing water from the Los Angeles Aqueduct, it was a 233-mile-long gravity-fed trough from the Owens Valley. When the dam collapsed, a one-hundred-foot high wall of water swept 54 miles west to the Pacific for five and a half hours, demolishing twelve hundred houses and ten bridges, knocking down power lines and killing around five hundred people. Bodies washed ashore as far south as San Diego.

MARCH 14, 1915: HOLLYWOOD TOURS

When Carl Laemmle opened Universal City, a city in name only, he invited the public to watch movie magic being made, welcoming them onto silent film stages and introducing stunt pilots and the stars. Promoters claimed that the opening would be so big, a battleship would sail up the Los Angeles River to fire a salute. The truth was more pedestrian, but the nickel entry fee included a chicken box lunch. Having an audience on live sets worked great until the 1920s, when sound films demanded quiet. Universal City was closed to outsiders until 1964, when it opened with a bang so loud it might have been a battleship salute to the newest world tourism destination.

MARCH 15, 1910: MAJOR BLOWOUT

When Union Oil Company Lakeview Gusher no. 1 erupted, the blowout became the largest oil spill in U.S. history. Over nine million barrels of

Union Oil Company at Bakersfield, California. Photograph by West Coast Art Company (circa 1910). *Courtesy Library of Congress.*

crude oil flowed like a river into an artificial lake for more than eighteen months. About 40 percent was reclaimed and sold, flooding the market and cutting the price of oil in the United States by half, to around thirty cents a barrel. The rest evaporated or seeped into the ground. California Historical Landmark No. 485 in Kern County identifies it as "America's most spectacular gusher."

MARCH 16, 2011: ROADWAY FATIGUE

A forty-foot length of Highway 1, known as the Pacific Coast Highway, fell into the ocean near an iconic bridge south of Carmel following several rainy days. The southbound lane disappeared completely, leaving the northbound lane dangerously unstable. This stretch of highway runs along the steepest coastal slope in the lower forty-eight states. People driving to the legendary vacation spot were rerouted inland while the road originally built between 1919 and 1937 was restored.

MARCH 17, 1878: TELEPHONE HISTORY

By one account, the first telephone exchange began in San Francisco with eighteen phones in the system. Another source claims the founding was on April 1, 1882. There was a telephone installed in San Francisco in 1872, but who could be called is unclear. In 1877, a phone call was placed over a fifty-eight-mile line connecting French Corral to French Lake, now known as Bowman Lake. The Los Angeles Telephone Company started in 1879 with seven subscribers. San Francisco's Chinatown opened an exchange in 1887 staffed by operators who spoke five Chinese dialects plus English.

MARCH 18, 1848: GOLD RUSH STATS

The *California Star*, San Francisco's first newspaper, reported that 812 people lived in the city—575 men, 177 women and 60 children. This did not count Indians or Mexicans. Eighteen months later, by December 1849, the city's

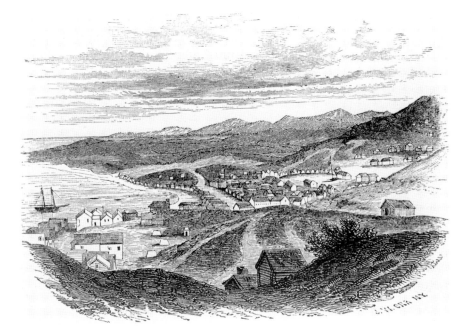

General view of San Francisco (winter 1848). *Courtesy Library of Congress.*

population had exploded to some 25,000. By 1850, more than 25 percent of the state's population was born outside the United States, close to the same percentage in 2010.

MARCH 19, 1887: POWERING SANTA BARBARA

Santa Barbara Electric Company installed electric arc lamps on State Street. But the two-thousand-candlepower lamps were too bright, so they were raised on masts to 125 feet. But then, moist air surrounded the exposed carbon rods at night, causing small explosions that kept everyone awake. Modern technology was improving. In 1886, the Visalia Electric Light and Gas Company had lit that town's July Fourth festivities with power generated by a wood-burning steam engine.

MARCH 20, 1999: LEGOLAND, YEAH!

When Legoland California in Carlsbad opened, it was the first Legoland outside of Europe. The owner, Merlin Entertainments, Europe's largest theme park company and second worldwide to Walt Disney Parks and Resorts, designed it like a Disney park, with themed rides and experiences: Dino Island, Duplo Village, Fun Town, Miniland USA, Castle Hill, Imagination Zone, Pirate Shores, Land of Adventure and Legoland Water Park. Some say Miniland USA includes a businessman mooning a presidential motorcade and a man sitting on a toilet in Grand Central Terminal.

MARCH 21, 1942: CAMP MANZANAR

Manzanar Detention Camp opened in a remote part of the Owens Valley, some 230 miles from Los Angeles, one of ten forced detention camps where some 110,000 people of Japanese ancestry were held during World War II. Life was a struggle in every respect. Tensions boiled over into a riot on December 5–6, 1942. Jeanne Wakatsuki Houston remembered her girlhood there in *Farewell to Manzanar* (1973). Ansel Adams photographed the camp and published a book, *Born Free and Equal* (1944), that sparked protests. Today, Manzanar is preserved as a National Historic Site.

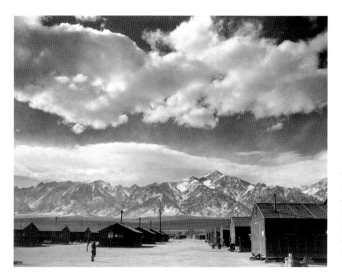

Manzanar street scene, clouds, Manzanar Relocation Center, California. Photograph by Ansel Adams (1943). *Courtesy Library of Congress.*

MARCH 22, 1875: NEWHALL TUNNEL

Fifteen hundred railroad workers, largely experienced Chinese laborers, started digging the San Fernando Tunnel at Newhall Pass. It would stretch 6,940 feet, making a gateway to Los Angeles. After the Transcontinental Railroad was completed in 1869, the next step was to lay tracks to Southern California. But the San Fernando Tunnel, plagued by cave-ins, took eighteen months to complete—and it was just one of the eighteen railroad tunnels through the Tehachapi Mountains. When it was done, Charles Crocker drove a golden spike at Lang Station in Soledad Canyon to celebrate the completion of the Southern Pacific Railroad in California.

MARCH 23, 1868: YOU SEE

The governor signed the Organic Act "to Create and Organize the University of California." The university was located in Oakland until Berkeley opened in 1873. Merced, the tenth and newest campus, opened in 2005. The Berkeley Campanile is the third-tallest bell and clock tower in the world. UCLA is distinguished by one of the most significant outdoor sculpture gardens in the country. As of 2016, UC faculty members and researchers have won sixty-two Nobel Prizes.

MARCH 24, 2001: FIGURE SKATING CHAMP

Michelle Kwan, born in Torrance, won her fourth World Figure Skating title on her way to becoming the most decorated figure skater in U.S. history. In all, she claimed two Olympic medals, five world and nine U.S. championships. She then leveraged those accomplishments into a series of major endorsements and starring roles in TV specials and ice tours. Since 2006, Kwan has served as a public diplomacy ambassador, representing American values, especially to young people and sports fans worldwide.

MARCH 25, 1851: MARIPOSA INDIAN WAR

James Savage, riding at the head of the Mariposa Battalion chasing Indians who destroyed his trading post, became the first white man to enter Yosemite Valley. He'd grown so rich from gold mining with Indian labor that, reportedly, he rolled a barrel of gold dust through a San Francisco hotel lobby. But he'd made enemies, and they burned his trading post and killed his laborers while he was away. Savage forced Chief Tenaya and the Ahwahnechee people from their mountain homes to live on a Fresno reservation. History was cruel to the first people of Yosemite Valley.

MARCH 26, 1825: MEXICAN REPUBLIC

Following Mexico's independence from Spain, a new constitution was ratified in Monterey, the colonial capital of Alta California. It meant life would continue as it had for most people. But the mission padres knew that was not true for them, and they refused to bless the new constitution with a religious service. They knew that the new Mexican government would break up the missions and place their lands and herds in private hands. They were right, and that was the beginning of the rancho period, still reflected in rancho place-names on California maps.

MARCH 27, 2007: PLASTIC BAGS

San Francisco became the first U.S. city to ban plastic grocery bags at grocery stores and supermarkets. It had recently banned Styrofoam food containers and encouraged using clean-fuel construction vehicles at city work sites. Plastic bags, beginning with sandwich bags, had been promoted as clean, environmentally friendly alternatives to paper bags until some 180 million were being distributed annually in San Francisco. What seemed like a good idea proved otherwise. What started in San Francisco became a state referendum in 2016.

MARCH 28, 1928: AIRMAIL DELIVERY

J.L. Rutledge, a Pacific Air Transport pilot carrying the U.S. mail, ran out of fuel and parachuted near Orinda in Contra Costa County. After he crashed, Rutledge retrieved the mail from the wreck and delivered it to the nearby post office. Pacific Air Transport was a pioneer airmail company with service from Seattle to Los Angeles with stops in Portland and Medford, Oregon, and San Francisco, Fresno, Bakersfield and elsewhere in California.

MARCH 29, 1887: NOVEL STOVE

Mary Birnbaum of Santa Barbara patented a stove. "The object of my invention is to construct a stove which may be placed in an arch in a partition of a building and arranged to heat two rooms." Exactly five years later, in 1892, Ada Van Pelt of Oakland, another inventive woman, patented a house letter box. "My invention relates to certain improvements in letter-boxes which are especially adapted for receiving mail-matter." Birnbaum wound up in bankruptcy court in 1907. Van Pelt, a temperance and suffrage activist, editor and lecturer, received several more patents, including for an electric water purifier when she was seventy-four years old.

MARCH 30, 1776: PALO ALTO

Juan Bautista de Anza, Spanish explorer, was returning to Mexico after establishing a military outpost at Yerba Buena, now known as San Francisco, when he camped at a place where he measured an enormous redwood tree "five and a half yards around." Palo Alto, the place de Anza named for the tall tree, now home to Stanford University, is in the center of Silicon Valley, known for technology and venture capital investment companies. That tree is still standing.

MARCH 31, 1998: STARCRAFT

StarCraft, a military science-fiction real-time strategy video game by Blizzard Entertainment, headquartered in Irvine, was released for Windows and debuted in South Korea, where today, professionals and teams play sponsored matches and some tournaments are televised on OGN. The series' popularity has spun off related games, novelizations, a board game and licensed collectible statues and toys, having developed into one of the most popular online games worldwide. StarCraft II: Wings of Liberty sold 1.8 million copies in the first forty-eight hours of release in 2010.

April

APRIL 1, 1976: APPLE

Steve Jobs, Steve Wozniak and Ronald Wayne founded Apple Inc. in Cupertino. Jobs and Wozniak met at the Homebrew Computer Club, an electronics hobby group, where they went to see a DYI computer kit. When Wozniak showed the group a better computer he had built more cheaply, Jobs saw a business opportunity. He sold his VW, and Wozniak sold his HP calculator, to raise startup funds. They also brought in Ronald Wayne as an investor. Wayne backed out twelve days later, selling his stake for less than $1,000—today, it would be worth billions.

APRIL 2, 1873: MODOC WAR

U.S. Army soldiers and Modoc warriors were at a stalemate after months of skirmishing. Their leaders held a parlay, but the meeting broke up with nothing resolved. Fighting had gone on for months as the army tried to force the Modocs back to the Klamath Reservation, where intertribal feuding that had forced them off awaited them. The fighting that winter delivered unprecedented defeats to the army. It was a tragic affair. Kintpuash, nicknamed "Captain Jack," murdered General Edward R.S. Canby and

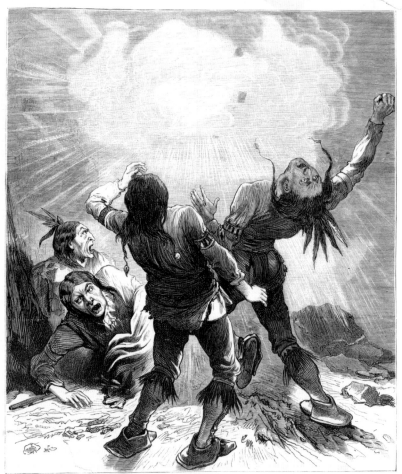

Oregon. The Modoc war—Schonchin and his associate "Bucks" killed by an exploding shell in the lava beds. Wood engraving in *Frank Leslie's Illustrated Newspaper* (May 10, 1873). *Courtesy Library of Congress.*

Reverend Eleaser Thomas at a peace meeting nine days later. Fighting continued through June, when Captain Jack and his men were captured. Six men were hanged, and the Modocs were sent away to Oklahoma.

APRIL 3, 1981: OSBORNE 1

The first successful portable computer, Osborne 1, debuted at the West Coast Computer Faire in San Francisco. Adam Osborne, who published some of the first computer manuals, recognized a market for a reasonably priced portable computer with bundled software. Although his machine was nearly as heavy as a sewing machine, featured a small screen and was not very fast, he sold eleven thousand units in the first eight months. Sales hit $1 million in September. But when a new model was announced too soon, it killed the sales of the Osborne 1, and the company stumbled toward bankruptcy—something later named the "Osborne effect."

APRIL 4, 1850: LA INCORPORATED

Los Angeles incorporated five months before California achieved statehood, part of the race to Americanize what had been Mexican territory. Sacramento was first (February 27, 1850), followed by Santa Barbara (April 9, 1850), Benicia, San Diego and San Jose (March 27, 1850), then Los Angeles. By 1850, Los Angeles was already an old town, founded in 1781 but changed little from its early days. It stayed small and remote until the 1880s, when railroad lines connected it to San Francisco and eastern markets. Since then, Los Angeles has become the most populous city in California, second nationally to New York.

APRIL 5, 1870: A BETTER PENCIL HOLDER

Annie J. Hall of San Francisco patented an improved pencil holder. "This invention consists of a rigid tube provided with fingers of peculiar construction, in combination with an elastic tube, as will be fully described."

Annie J. Hall of San Francisco. "Improved pencil holder." U.S. patent number 101,457. *Courtesy U.S. Patent and Trademark Office.*

Lead pencils, originating with the ancient Roman stylus, had improved throughout the nineteenth century in England and Europe, and their machine production began in the United States after the Civil War, largely in factories in New York and New Jersey. Hall's invention addressed the correct way to hold a pencil as an aid to proper penmanship.

APRIL 6, 1937: FAKE PLATE OF BRASS

At a meeting of the California Historical Society, it was announced that a legendary piece of brass reportedly left by Sir Francis Drake was found near San Francisco Bay. In 1579, after plundering Spanish ships and filling his own ship's hold with gold, Queen Elizabeth's privateer set sail up the Pacific coast on the first circumnavigation of the globe. He decided to return to England by sailing west to avoid Spanish ships hunting for him to collect $6.5 million for his head. North of San Francisco, he put into a bay to repair his ships. He thumbed his nose at Spain by claiming the land for England, naming it New Albion and supposedly leaving behind an inscribed plate of brass as proof. What was found in 1937, however, was a fake.

Sir Francis Drake. Engraving published by William S. Orr & Co., London (no date). *Courtesy Library of Congress.*

APRIL 7, 1926: OIL TANK FARM INFERNO

Fire tornadoes swirled around a nine-hundred-acre San Luis Obispo oil tank farm that had been struck by lightning. It was the largest farm of its kind

in the world. Unbelievably, only two people died in the initial explosion, which threw burning timbers two miles away. The wind from the fire broke windows, collapsed houses and uprooted trees. Over four days, thousands of whirlwinds shot flames one thousand feet into the sky. Over the next two weeks, the burning oil that covered nine hundred acres of land turned into a flaming river. More than eight million barrels of oil were lost in the worst environmental disaster in central coast history.

APRIL 8, 1986: MAYOR EASTWOOD

Clint Eastwood, actor and director, was resoundingly elected mayor of Carmel-by-the-Sea, a small coastal tourist mecca. He ran on a nonpartisan platform aimed at overturning the "ice cream cone law" that restricted the sale of fast food, like ice cream cones. The man who played Dirty Harry and famously said "Make my day" advertised "Bringing the Community Together." Eastwood's tenure produced beach walkways and a much-needed library annex before he returned his attention to Hollywood.

Two Spanish American girls dressed in fiesta costumes eating popsicles in Taos, New Mexico. Photograph by Russell Lee (July 1940). *Courtesy Library of Congress.*

APRIL 9, 1905: ON A STICK

The author has heard but cannot verify that eleven-year-old Frank Epperson of San Francisco invented the Popsicle when he left a mixture of sugary soda powder with water outside overnight and it froze. He licked it off the wooden stirrer in the morning. Eighteen years later, he patented his frozen treat on a stick and started selling what he called Epsicles in seven fruit flavors. His kids called them "Pop's 'sicles." A couple of years after that, down on his luck, he sold the rights to the Joe Lowe Company in New York City, and the rest is history.

APRIL 10, 1953: 3-D FLICKS

Warner Bros. premiered the first color 3-D film from a major U.S. studio just days after the first black-and-white 3-D feature. *House of Wax*, a horror film starring Vincent Price, told the story of a criminally insane sculptor who murdered people in order to use their corpses in recreations at his wax museum. It was a twisted remake of *Mystery of the Wax Museum* (1933) and shares a title with a 2005 film featuring a different plot.

APRIL 11, 1976: NO. 1 APPLE

The original Apple Computer, later known as the Apple I, was released. Steve Wozniak designed and hand-built the computers without a transformer, monitor, audio or video display or even a keyboard. They went on sale in July for $666.66, a price Wozniak chose for its repeating digits. A fully operational unit, one of the fifty he built, sold at auction for $815,000.00 in 2016.

APRIL 12, 1965: MR. TAMBOURINE MAN

The Byrds, a Los Angeles band, released Bob Dylan's song "Mr. Tambourine Man" as a single. Dylan had released it on the album *Bringing It All Back Home*. But the Byrds turned it into the first folk-rock smash hit in the United States and England. Their rendition not only fused folk and rock motifs, but it also became a musical model mimicked by many contemporary bands, setting intellectual lyrics to jangly guitars.

APRIL 13, 1964: "CALL ME MR. TIBBS"

Sidney Poitier became the first African American male to win the Best Actor award at the Academy Awards in Los Angeles for *Lilies of the Field* (1963). Three years later, he starred in three iconic films dealing with race relations: *Guess Who's Coming to Dinner* (1967), *To Sir, with Love* (1967) and *In the Heat of the Night* (1967).

APRIL 14, 1846: DONNER PARTY SETS OUT

The wagon train known as the Donner Party began its westward journey from Springfield, Missouri. The original group was composed of three families headed by George and Jacob Donner, brothers, and James Reed. Each had three covered wagons and teamsters to drive the oxen that pulled them. The Reeds also had two servants. Other families joined them along the trail. They made a series of tragic decisions due to ignorance and inexperience and became snowbound in the Sierra Nevada for months. Half of the party's members perished.

APRIL 15, 1873: ARMY LOSSES

One U.S. Army officer and six soldiers were killed and thirteen wounded in two days of fighting Modoc warriors led by Kintpuash, nicknamed "Captain Jack," at the Second Battle of the Stronghold. Captain Jack had killed Major Edward Canby and Reverend Eleaser Thomas during a peace conference four days earlier. Fighting raged for months as the army tried to force the Modocs back to the Klamath Reservation, cutting the tribe's water supply to force them from the lava beds. But they escaped. During this time, a Modoc boy was killed when he tried to open a cannonball with a hatchet, and several women died from sickness. Fighting continued until June. Eventually, Captain Jack and five warriors were hanged and the other Modocs were sent to Oklahoma.

APRIL 16, 1954: LA FREEWAYS

The Hollywood Freeway opened a shortcut from the Los Angeles Basin to the San Fernando Valley, a project thirty years in the making. The first section, opened in 1940, featured a median strip for electric trolleys. The whole thing was a mixed blessing. A quarter million people were displaced and a neighborhood demolished to link communities in the Los Angeles area with an extended freeway system. The Hollywood Freeway itself reached double the designed capacity within a year, becoming one of the busiest freeways in the United States.

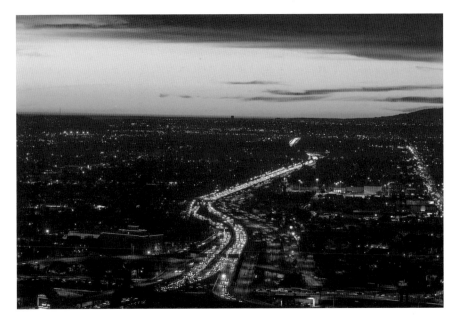

Nighttime skyline of Los Angeles, California, looking north over the Hollywood Freeway. Photograph by Carol Highsmith (2013). *Courtesy Library of Congress.*

APRIL 17, 1937: CARTOON CHARACTERS

Porky Pig and Daffy Duck debuted in "Porky's Duck Hunt," a Warner Bros. cartoon. Both characters were voiced by Mel Blanc, known as the "Man of a Thousand Voices." Blanc, born in San Francisco, was attracted to the stage as a young man. He led an orchestra, performed vaudeville comedy and did radio work before he began voicing cartoons, eventually speaking for Bugs Bunny, Tweety Bird, Sylvester the Cat, Yosemite Sam, Foghorn Leghorn, Marvin the Martian, Pepé Le Pew, Speedy Gonzales, Wile E. Coyote, the Tasmanian Devil and many others.

APRIL 18, 1906: THE BIG ONE

When the San Francisco Earthquake and Fire struck, people from Oregon to Los Angeles and central Nevada felt what turned into the largest natural disaster in U.S. history. Some three thousand people died and more than 80 percent of San Francisco burned during the next few days. One of

the largest fires began when a woman who felt the earthquake danger had passed lit her gas stove to make breakfast for her family. The conflagration was dubbed the "Ham and Eggs Fire." Well over half of the city's residents were forced to live in tents and small cottages—some for years. One of those cottages sold for $765,000 in 2014.

APRIL 19, 1934: AMERICA'S SWEETHEART

Stand Up and Cheer! debuted, launching Shirley Temple's career. The storyline about boosting the nation's morale during the Great Depression perfectly reflected the reality of the time. By year's end, the Santa Monica–born child star, who was featured in ten movies, grew so famous that she feared being kidnapped or mobbed. Known as "America's Sweetheart," Temple was Hollywood's biggest star through 1938. Her popularity was such that merchandizers capitalized on it by licensing Shirley Temple dolls, dishes and clothing. The sale of dolls alone reached $45 million by 1941. Temple later shared her nickname with Mary Pickford.

APRIL 20, 1942: INTERNMENT

Tulare Assembly Center opened. The fenced transfer compound in the Central Valley was part of the detention of some 110,000 Californians of Japanese ancestry during World War II. People lived in animal stalls and sheds on the agricultural fairgrounds; 200 people shared one washing room. Most, who lost everything but what they could carry, lived at Tulare Assembly Center for four months before they were sent to the Gila River camp in southern Arizona, where over 13,000 people were held for the rest of the war.

APRIL 21, 1782: ROYAL PRESIDIO

Construction began on the Royal Presidio of Santa Barbara with a blessing by Padre Junípero Serra, founding father of Alta California's missions. The

presidio, or military outpost, was one of five built to defend the territory. Others were at San Diego, Monterey, San Francisco and Sonoma. The post, with sixty-one officers and men in 1783, never fought in battle, surrendering without a fight during the Mexican-American War (1846). Earthquakes and erosion took a toll on the structures until El Presidio de Santa Bárbara State Historic Park was established to preserve and reconstruct the fort, now in the middle of downtown Santa Barbara.

APRIL 22, 1970: EARTH DAY DAWNS

The first Earth Day celebration began, partly in reaction to a massive oil spill off the Santa Barbara coast. The organizers took a page from anti–Vietnam War demonstrations to orchestrate protests against what was happening to the environment. Their idea, since then, has grown into a global movement motivating people to plant trees, reduce their carbon footprint and find ways to make the environment healthier. Partly as a result, we have the Clean Air Act, the Water Quality Improvement Act and the Endangered Species Act.

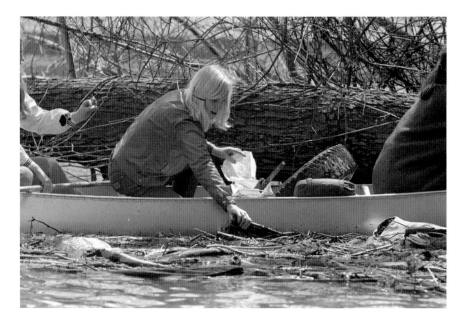

Girl Scout in canoe, picking trash out of the Potomac River during Earth Week. Photograph by Thomas J. O'Halloran (April 22, 1970). *Courtesy Library of Congress.*

APRIL 23, 1860: PONY EXPRESS DELIVERY

When a Pony Express rider, waylaid by Indians, was late and missed the boat at Benicia, Thomas Bedford was hired on the spot to relay the San Francisco–bound mail. He boarded the ferry with his horse, but it lost a shoe. So he borrowed a horse from Casemoro Briones, a blacksmith, and delivered the mail to the ferry at Oakland; it arrived in San Francisco, nine hours and fifteen minutes from Sacramento. A local newspaper reported, "the Pony did not shed his shoes, his rider did not break his neck, nor was there any appreciable smell of fire upon his cloths when he came in."

APRIL 24, 1908: MURDOCK'S ROAD TRIP

Mr. and Mrs. Jacob Murdock left Pasadena on the first cross-country family car trip. Jacob, his wife, Anna, their three children, a mechanic and a friend rode in a Packard convertible. Because there were no gas stations, Murdock wrote orders for gasoline to be delivered to stores along the way. He did all the driving himself. They rested on the Sabbath and rested a couple days at their home in Pennsylvania before driving into New York City thirty-two days, five hours and twenty-five minutes later.

APRIL 25, 1961: INTEGRATED CIRCUITS

Robert Noyce won a legal contest, defeating Jack Kilby for ownership of an integrated circuit patent, an early step toward the personal computer revolution. Noyce was the right man in the right place at the right time. His engineering gifts complemented his entrepreneurial skills to help launch Fairchild Semiconductor and Intel Corporation, cornerstones of what became known as Silicon Valley, where Noyce became known as the "mayor."

APRIL 26, 1856: NATAQUA

Peter Lassen led a band of Susanville-area settlers to declare the independent territory of Nataqua, a Paiute name. State boundaries were still being drawn, and the secessionists claimed a section of northeast California and western Nevada for their own. They wrote laws, held elections and initiated public works. Lassen was murdered in 1859. When a posse arrived on February 15, 1863, to collect California taxes, the independence movement ended with a gun battle. To this day, an independent streak still characterizes many who live on the eastern slope of the Sierra Nevada.

APRIL 27, 1942: INTERNMENT

Japan's attack on Pearl Harbor in December 1941, followed by President Roosevelt's Executive Order 9066 ten weeks later, led to the forcible relocation and internment of some 110,000 Californians of Japanese ancestry during World War II. The first prisoners arrived at Salinas Assembly Center, built on rodeo grounds, and the Tanforan Assembly Center, which is now a shopping mall south of San Francisco.

APRIL 28, 1973: RAILCARS EXPLODE

Seven thousand bombs intended for the Vietnam War exploded on railcars when a hot wheel sparked, igniting one of the car's oak floor as the train traveled by the town of Antelope, near Sacramento. Explosions continued for eighteen hours, damaging five thousand structures and largely leveling the town. Hundreds of residents were injured, but nobody was killed. Unexploded ordnance was uncovered during a remodeling project years later. The accident prompted passage of the Transportation Safety Act (1974), calling for railcar wheels to have non-sparking brake shoes and spark shields.

APRIL 29, 1953: 3-D TV

Space Patrol became the first experimental 3-D TV broadcast in the United States. Initially branded a children's program for the LA market, its popularity spread across demographics, prompting cross-platform marketing with radio and comic books, and it was beamed to the East Coast. *Space Patrol* featured the futuristic adventures of Commander Corry and his young sidekick, Cadet Happy, fighting thirtieth-century super villains in outer space. Over the show's five-year run, KECA-TV produced some eleven hundred episodes that ran for fifteen and thirty minutes.

APRIL 30, 1927: WALK OF FAME

Douglas Fairbanks and Mary Pickford, two of Hollywood's leading movie stars, became the first celebrities to leave footprints in front of Grauman's Chinese Theatre when they stepped in wet concrete. Then for fun, they signed them. Thirty years later, to make way for the Hollywood Walk of Fame, their footprints and signatures were taken up by jackhammers. Nobody wanted them, so they were held in a private storage and forgotten until they were found in 2016, beginning a lengthy process to return their footprints to the Hollywood Walk of Fame.

May

MAY 1, 1892: ANGEL ISLAND

A U.S. Quarantine Station opened on Angel Island in San Francisco Bay to fumigate ships from foreign ports and detain immigrants suspected of carrying diseases. Nearly twenty years later, a U.S. Immigration Station was established there as an entry point for some three hundred thousand immigrants from eighty-five nations. It is known as the Ellis Island of the West. Chinese immigrants held there for years carved poems into the walls, expressing frustration, anger and despair. You can visit the ruined Quarantine Station, a National Historic Landmark, within Angel Island State Park.

Poetic verse carved into the wall of the detention barracks at Angel Island Quarantine Station in San Francisco Bay. Photograph by Carol M. Highsmith (May 2013). *Courtesy Library of Congress.*

MAY 2, 1946: BATTLE OF ALCATRAZ

The Battle of Alcatraz at the Federal Penitentiary in San Francisco Bay started when three convicts attempted to escape. After their plans fell apart, they released more inmates and took nine guards hostage. The warden responded by calling in two platoons of marines. In the gunfire that rang out over the next two days, two guards and three inmates were killed; eleven guards and a convict were wounded. Several films tell this story, including *Six Against the Rock* (1987), based on Clark Howard's semi-fictional book. Visitors can tour Alcatraz to learn more about this.

MAY 3, 2010: STUDENTS PROTEST

Some twenty students began a hunger strike in front of UC Berkeley's California Hall. They demanded the school denounce Arizona's new immigration law, drop charges against protesters arrested during an anti–fee hike occupation, rehire laid-off janitors and declare Berkeley a sanctuary for undocumented immigrants. Earlier that week, some one thousand students rallied and resolved to set up an encampment near the administration building. It was part of the Occupy California movement that had started at UC Santa Cruz the previous fall and swept across university campuses statewide.

MAY 4, 1851: SYDNEY DUCKS

Around midnight on May 3, a gang of Australian ex-convicts known as Sydney Ducks, intent on looting, set fire to a store on San Francisco's Portsmouth Square. When the flames spread unchecked, the fifth major fire in eighteen months destroyed some two thousand buildings with a value at around $12 million, equivalent to some $372 million today. Because the city was new, there was no fire department or police force. A band of vigilante citizens formed the Committee of Vigilance, hanged some outlaws and drove others from town. Ducks lived in a part of town called "Sydney-Town" at the foot of Telegraph Hill. Later it was dubbed the Barbary Coast, a notoriously dangerous neighborhood where sailors were drugged, kidnapped and shanghaied.

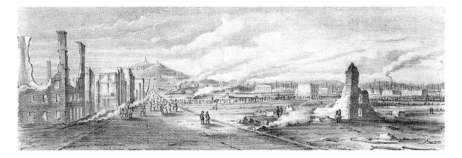

General view of the burned district in San Francisco following the 1851 fire. Historic American Buildings Survey. *Courtesy Library of Congress.*

MAY 5, 1965: GRATEFUL DEAD

The Grateful Dead, then known as the Warlocks, played their first show at Magoo's Pizza in Menlo Park. Phil Lesh, the bassist, heard that another band called the Warlocks was releasing records, so they knew they needed a new name. Stories vary, but all agree that Jerry Garcia, guitarist and singer, found the band's new name by opening a dictionary at random. He said, "I opened it and there was 'Grateful Dead,' those words juxtaposed. It was one of those moments, you know, like everything else went blank, diffuse, just sort of oozed away, and there was GRATEFUL DEAD in big, black letters edged all around in gold, man, blasting out at me, such a stunning combination. So I said, 'How about Grateful Dead?' And that was it."

MAY 6, 1941: USO

Bob Hope led a handful of celebrities in his first USO show at March Field near Riverside. This was the first of fifty-seven United Service Organization tours he headlined for over half a century. They featured comedians, singers, actors and actresses who volunteered time and talent to troops and families around the world. Today, USO shows take place in over 160 locations in fourteen countries around the world. They've been performed during World War II, the Korean War, the Vietnam War, the Lebanon Civil War, the Iran-Iraq War and the Persian Gulf War.

MAY 7, 1846: RANCHO DEED

Rancho Boca de la Playa was granted by Governor Pío Pico to Emigdio Vejar, the government's supervisor of Los Angeles and Mission San Juan Capistrano. Vejar's rancho's name, meaning "mouth of the beach," encompassed 6,607 acres in today's Orange County, stretching along the coast from San Juan Capistrano to San Clemente. The Pablo Pryor Adobe, still owned by Vejar's descendants, is among the oldest adobe homes in California. You'll find it in San Juan Capistrano next to the Marriott Resident Inn.

MAY 8, 1829: ESTANISLAO REVOLT

Spanish soldiers fought hundreds of Native Americans, who escaped from Bay Area missions and built a natural fort among the thickets in a bend of the Stanislaus River, an area later named for the rebellion leader, a man christened "Estanislao." He was a natural leader, some six feet tall and highly intelligent. Estanislao fled Mission San Jose in 1827 and, with his followers, began raiding missions and ranchos. Repeated military expeditions failed to defeat them until a force led by General Mariano Vallejo burned them out. Estanislao survived, returned to Mission San Jose, asked for forgiveness and lived the rest of his life as a teacher.

MAY 9, 1934: LONGSHOREMEN STRIKE

The West Coast Longshoremen's Strike began in San Francisco when negotiations broke down over whether waterfront laborers would be represented by a union. To make their point, longshoremen shut down seaports all along the Pacific coast for three months. They demanded a six-hour workday and a union hiring hall on the waterfront. Tensions came to a head on

Striking longshoremen during the waterfront strike in San Francisco, California. Photograph by Dorothea Lange (March 1937). *Courtesy Library of Congress.*

July 5, when San Francisco police officers shot tear gas into the crowd and charged on horseback. That "Bloody Thursday" led to a four-day general strike which paralyzed San Francisco, finally resulting in the unionization of all U.S. Pacific seaports.

MAY 10, 1846: DONNER PARTY LAUNCH

The Donner and Reed family wagons gathered in Independence, Missouri, the start of the Oregon Trail, and spent two days preparing for what became a tragic journey. The leaders would make fateful decisions and follow inaccurate advice regarding a shortcut that did not exist. That winter, eighty-seven people would be trapped for months by deep snow in the Sierra Nevada. Nearly half starved, and several survivors resorted to cannibalism.

MAY 11, 1880: BATTLE OF MUSSEL SLOUGH

The Battle of Mussel Slough, a gunfight pitting U.S. Marshals and deputies against San Joaquin farmers, left seven farmers dead in a land dispute with the Southern Pacific Railroad. The farmers had developed and irrigated the arid land for agriculture. But the railroad claimed it owned the land and won its case before the U.S. Supreme Court. The incident, widely recognized as an example of corporate greed and abuse, inspired Frank Norris's book *The Octopus: A Story of California* (1901).

MAY 12, 1912: BEVERLY HILLS HOTEL

One of the world's most iconic hotels, the Beverly Hills Hotel, opened and, for over a century, has been a legendary haven for the rich and famous. Elizabeth Taylor's father ran an exclusive art gallery there. Howard Hughes lived there reclusively on and off for thirty years. It was featured on the cover of the Eagles' album *Hotel California* (1976). But after the Sultan of Brunei bought it in 2014 and began imposing restrictive Sharia law, Hollywood stars and their supporters turned against it.

MAY 13, 1960: STUDENTS PROTEST

The spark of the free speech movement ignited when UC Berkeley students protested a meeting of the House Un-American Activities Committee at San Francisco City Hall, where Bill Mandel was forced to explain his KPFA radio broadcasts about the press in the Soviet Union. In 1953, Mandel famously stood up to Senator Joseph McCarthy's political witch hunt, telling him, "This is a book-burning! You lack only the tinder to set fire to the books as Hitler did twenty years ago, and I am going to get that across to the American people!" Mandel was accused of being a member of the Communist Party. Police at San Francisco City Hall turned firehoses on student protesters and violently dragged them down the marble steps.

MAY 14, 1769: ROYAL PRESIDIO

The Royal Presidio of San Diego, a Spanish fort, was established by Gaspar de Portolá. It was the first European settlement on the North American Pacific coast and became the base for colonizing Alta California. Native American warriors attacked the mission soon after it was begun, wounding four Spaniards and killing a boy. Afterward, the Spaniards built a defensive stockade protected by two cannons. One was pointed at San Diego Bay, the other to the Indian village nearby. One of the cannons, "El Jupiter," is on display at the Serra Museum in San Diego.

MAY 15, 1930: AIRLINE STEWARDESS

Ellen Church became the first female airline stewardess. Although Church was a trained pilot and a nurse, Boeing rejected her application to fly and instead hired her to help calm passengers' fear of flying. Her first flight was a twenty-hour expedition from Oakland/San Francisco to Chicago, carrying fourteen passengers and making thirteen stops. Stewardesses, then called "sky girls," were required to be registered nurses, "single, younger than 25 years old; weigh less than 115 pounds and stand less than 5 feet, 4 inches tall." An Iowa airport, Ellen Church Field, is named in her honor.

MAY 16, 1903: WYMAN'S ROAD TRIP

George Adams Wyman departed San Francisco on the first cross-country motorcycle trip. The twenty-five-year-old Oakland native left wearing a three-piece wool suit and cap, riding a 1.25-horsepower, 90cc motorcycle that got 120 miles per gallon. He could also pedal it. The motor was completely shot by the end of his journey, so he pedaled the last 150 miles to New York City, arriving on July 6, 1903. Wyman attended the first meeting of the Federation of American Motorcyclists, then rode the train back to California.

MAY 17, 1851: LA'S FIRST PAPER

La Estrella de Los Angeles, the first newspaper published in Los Angeles, made its debut, printed in English and Spanish. It reported that Los Angeles County had 8,329 residents, including "Indians and foreigners." A yearly subscription cost ten dollars, payable in advance. Circulation was around 250 copies per issue. Henry Hamilton took over the paper in 1856. During the Civil War, the Confederate-sympathizing editor wrote so critically of President Lincoln that the Star was banned from the U.S. mail. Hamilton was charged with treason and wound up in the military prison on Alcatraz Island.

MAY 18, 1841: THE KELSEYS

Seventeen-year-old Nancy Kelsey and her husband, Ben, with their one-year-old daughter, joined the Bartleson-Bidwell expedition, the first wagon train to California. The first white woman to travel from Missouri to California, Kelsey gave birth to one of her nine children on the trail. The party got caught up in the Bear Flag Revolt, and she sewed a flag with a bear, a star and a stripe on it for which she is called the "Betsy Ross of California." Ben was a violent man who enslaved Native Americans to dig for gold and is said to have provoked the massacre of Pomo people at what became called Bloody Island.

MAY 19, 1882: SAN DIEGO LIBRARY

San Diego Public Library opened for business in a rented space at the Commercial Bank building, later moving into the first Carnegie library west of the Mississippi River. Clara Breed, a children's librarian, made gifts of paper and stamped envelopes to Japanese American children and asked them to write to her before they were taken away to World War II internment camps. Their letters form the basis of *Dear Miss Breed: True Stories of the Japanese American Incarceration during World War II and a Librarian Who Made a Difference* (2006).

Detail of farmer's blue jeans, boots and spurs. This man was once a cowboy and still prefers the cowboy's dress. Pie Town, New Mexico. Photograph by Lee Russell (June 1940). *Courtesy Library of Congress*.

MAY 20, 1873: JEANS

Thinking of durable work pants for miners, Levi Strauss and Jacob Davis patented the process of reinforcing their pants with rivets for strength, a design they called "waist overalls." Exactly one year later, Strauss began selling denim jeans with copper rivets priced at $13.50 per dozen. Their cloth was originally imported from Nimes, France, which gives us the term denim, as in "de Nimes."

MAY 21, 1980: STAR WARS

Star Wars: Episode V: The Empire Strikes Back was released. George Lucas produced it largely at Skywalker Ranch in San Rafael with many improvised sounds. Reportedly, the sound of Darth Vader's shuttle door opening is based on cell doors slamming at Alcatraz Prison. The sound of Vader's helmet lowering onto his body was made by someone putting their hand over a sucking vacuum cleaner. Mynocks sound effects were from horse noises played backward. The sound of R2-D2 moving came from a car window motor. And the Tauntauns' sound was provided by an Asian sea otter named Moda.

MAY 22, 1873: MODOCS SURRENDER

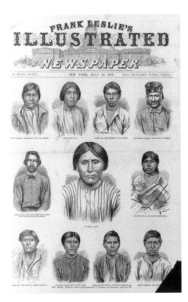

A group of Modoc warriors, women and children, but not their leader, Kintpuash, known as Captain Jack, surrendered to U.S. Army soldiers at Infernal Caverns. The Modocs had fled from the Klamath Reservation, where they were forced to live and were treated unjustly. In a series of running battles that lasted for months, Modoc warriors used their knowledge of the unique volcanic landscape to repel repeated attacks by the soldiers. In the end, Kintpuash and five Modoc warriors were hanged and the others sent to Oklahoma Indian Territory and held prisoner there until 1909. You can visit the cinder cones, tubes and battle sites at Lava Beds National Monument.

The Modoc Indians. Wood engraving from photographs taken by Carleton Watkins, San Francisco, published in *Frank Leslie's Illustrated Newspaper* (July 12, 1873). *Courtesy Library of Congress.*

MAY 23, 1835: LA, THE CAPITAL

The Mexican Congress promoted El Pueblo de Nuestra Señora de los Angeles de Porciuncula, known today as Los Angeles, from a pueblo to a ciudad, then made it the colonial capital of Alta California. The recognition reflected political struggles between southern and northern Californians, still a reality today. Southerners resented the influence of Monterey, the original capital, so they managed to move the capital to their geographic power base. The political gamesmanship continued, and Monterey soon reclaimed its position as the capital.

MAY 24, 1976: TABLES TURN

In a historic first, red and white wines from California beat French classics in a blind tasting contest called the "Judgement of Paris." Only one journalist,

American George Taber, witnessed the historic event. After he reported the result, disbelief was so intense that the story did not appear in the French press for several months. Taber was banned from subsequent French wine-tasting competitions for a year. The contest marked a major milestone in the development of the modern California wine industry, valued at some $35 billion in 2012. The "Judgement of Paris" features dramatically in the movie *Bottle Shock* (2008).

MAY 25, 1907: INYO NATIONAL FOREST

President Theodore Roosevelt established the Inyo National Forest near Bishop. It ranges over the Eastern Sierra Nevada through the White Mountains into Nevada. It is home to Mount Whitney, the highest peak in the continental United States, and Methuselah, the world's oldest tree, which grows in the Ancient Bristlecone Pine Forest atop the White Mountains. The national forest borders Sequoia and Kings Canyon National Parks as well as Yosemite National Park. Together, the parks protect some 1.5 million acres of wilderness. Dramatic landscapes in the Inyo National Forest form cinematic vistas in the films *Nevada Smith* (1966), *Will Penny* (1968), *Joe Kidd* (1972) and *High Plains Drifter* (1973).

MAY 26, 1853: SPIDER DANCER

Lola Montez, the Gold Rush femme fatale, made her theatrical debut in San Francisco. The dancer-actress, born Marie Dolores Eliza Rosanna Gilbert in Ireland, reinvented herself as a Spanish dancer. She was notorious for performing the exotic "Spider Dance," which was banned in some communities. Her notoriety was burnished by ownership of a pet grizzly bear that she walked on a silver leash. Montez is portrayed in numerous books and films and is said to have been the inspiration for a character in Arthur Conan Doyle's Sherlock Holmes story "A Scandal in Bohemia." While living in Nevada City, Montez mentored Lotta Crabtree, the famous child actress, without clouding the youngster's reputation.

"Lola has come! Enthusiastic reception of Lola by American audience." Lithograph by David Claypoole Johnston (1852?). *Courtesy Library of Congress.*

MAY 27, 1971: UCLA HOOPS

The UCLA Bruins won the NCAA basketball championship, a fifth consecutive title in the John Wooden era. His UCLA teams won a total of 620 games in twenty-seven seasons, including four perfect 30-0 seasons. His teams captured ten NCAA titles during his last twelve seasons, including seven in a row from 1967 to 1973. The quotable coach, known as the "Wizard of Westwood," said, "Things turn out best for the people who make the best of the way things turn out."

MAY 28, 1892: TREE HUGGERS UNITE!

The Sierra Club was formed during a meeting at Warren Olney's law office in San Francisco. The founding 182 members elected John Muir the first president. Their initial campaign focused on defending boundaries

Dan Tachet, Sierra Club cook during its outings.
Bain News Service (February 20, 1925).
Courtesy Library of Congress.

established for Yosemite National Park in the face of a proposal to reduce them. As the first environmental lobby, it pressured the U.S. Congress to establish Mount Rainier National Park in 1899 and preserve the North Grove of Calaveras Big Trees in 1900. Its success was reflected in President Theodore Roosevelt's visit to Yosemite National Park with Muir in 1903. The Sierra Club today is among the largest, most influential environmental organizations in the world.

MAY 29, 1848: EARLY CALIFORNIA PAPERS

According to the *Californian*, the state's first newspaper, everybody was suffering from gold fever, which is why it announced a suspension of publication—its staff had run off to the gold fields. The printing press was sold to the *Alta California*. Newspapers cropped up quickly during the Gold Rush years. Exactly three years later, the *Star* appeared in Los Angeles, then the *Herald* in San Diego twelve days later. The *Herald* debuted with four pages that ran 112 advertisements, 91 from San Francisco firms and 21 from San Diego businesses.

MAY 30, 1908: "THAT'S ALL, FOLKS"

Melvin Jerome "Mel" Blanc, legendary voice actor, was born in San Francisco. He was the voice of Bugs Bunny, Elmer Fudd, Porky Pig and all the other Warner Bros. leading male cartoon characters except for Elmer Fudd. His credits, including for Hanna-Barbera, are too many to list. To ensure that nobody forgets his work, "That's All, Folks" is inscribed on his tombstone.

MAY 31, 1932: STANDARD OIL

SoCal, formerly named Standard Oil of California, struck oil in Bahrain. That was the first time an American firm discovered oil in the Middle East after Great Britain and France ended the exclusion of American companies from the region. SoCal drilled in Bahrain and Saudi Arabia under the corporate identity of the California-Arabian Standard Oil Company. Later, Texaco purchased a 50 percent stake in the deal. California-Arabian Standard Oil then morphed into Aramco before Exxon and Mobile bought ownership stakes. King Abdulaziz of Saudi Arabia threatened to nationalize his country's oil facilities in 1950 in order to force Aramco to share its profits equally with his treasury. By 2005, Saudi Aramco had grown into the most valuable company in the world, with an estimated value of $781 billion.

June

JUNE 1, 1899: CAMP CURRY

David Curry and Jenny Curry, known as "Mother Curry," opened Camp Curry at Yosemite National Park. Both being teachers, they recognized the need for affordable accommodations for people of moderate means at the park, established in 1890. Getting to the park was too expensive for most people, so the Currys advertised "a good bed and clean napkin with every meal" for two dollars a day (roughly fifty-seven dollars in today's terms). This was half the price of staying at the Sentinel Hotel. Their plan succeeded. Many guests stayed for a month, forming the nucleus of a community whose descendants still return every summer.

JUNE 2, 1876: BANDIT POET

Charles Earl Boles, the English-born gentleman bandit known as Black Bart, twice left doggerel poems at the scenes of his twenty-eight Wells Fargo stagecoach holdups. His third robbery took place in Siskiyou County, five miles north of Cottonwood. Black Bart was different from other highwaymen in that he did not ride a horse, never fired a weapon and was uncommonly courteous to his victims. He was finally arrested when his handkerchief was found at a crime scene, then traced to a San Francisco laundry that identified him. At the scene of holdup number five (July 25, 1878), he left the following:

Here I lay me down to sleep
To wait the coming morrow,
Perhaps success, perhaps defeat,
And everlasting sorrow.
Let come what will, I'll try it on,
My condition can't be worse;
And if there's money in that box
'Tis munny in my purse.

JUNE 3, 1956: BAD-BAD ROCK 'N' ROLL

Santa Cruz city officials banned rock 'n' roll at public gatherings on the grounds that the music was "Detrimental to both the health and morals of our youth and community." The edict was in response to a dance party held at the Santa Cruz Civic Auditorium attended by some two hundred teenagers the previous Saturday night. It featured the Los Angeles band Chuck Higgins and his Orchestra with its hit record "Pachuko Hop." When Santa Cruz police checked in on the event, they found teens "engaged in suggestive, stimulating and tantalizing motions induced by the provocative rhythms of an all-negro band." The racist implications of the ban are obvious.

JUNE 4, 1942: CAPITOL RECORDS

Johnny Mercer, Buddy DeSylva and Glenn Wallichs—songwriters, producers and businessmen—launched Capitol Records in Los Angeles. It was the first West Coast–based label in the country and pioneered the practice of promoting airplay by giving free records to radio DJs. By 1946, Capitol Records had sold forty-two million records and developed into a major record label. It struck gold by signing the Beach Boys in the early 1960s. By 2014, Capitol Records was second in terms of the music market share and claimed all four major awards at the Grammys.

Capitol Records Tower near the corner of Hollywood and Vine, Los Angeles, California. Photograph by Carol M. Highsmith (2012). *Courtesy Library of Congress.*

JUNE 5, 1943: ZOOT SUIT RIOTS

Ethnic violence pitting Anglo sailors and soldiers against Mexican American young men broke out in Los Angeles and continued for days. The Zoot Suit Riots were grounded in historic prejudice. The attacks unleashed anger against Mexican American men who were tarred as symbolically unpatriotic because they wore zoot suits, made with luxurious amounts of fabric during a time of rationing. The Zoot Suit Riots seemed to ignite copycat attacks against Latinos elsewhere in the United States that year.

Zoot Suiters lined up outside Los Angeles jail en route to court after feud with sailors. Photograph by Acme Newspictures, Incorporated (June 9, 1943). *Courtesy Library of Congress.*

JUNE 6, 1978: PROP 13

The passage of Proposition 13, officially named the People's Initiative to Limit Property Taxation, an amendment to the state constitution, reduced California property taxes by 57 percent. That precipitated a long, downward spiral in state budgets. It not just lowered property taxes— Proposition 13 also required a two-thirds majority in both legislative houses to pass future tax increases. Partly as a result, California public school budgets, which ranked among the highest in the nation in the 1960s, fell to among the lowest by 2014.

JUNE 7, 1909: AMERICA'S SWEETHEART

Mary Pickford, born Gladys Louise Smith and nicknamed "America's Sweetheart," made her screen debut at the age of sixteen in *The Violin Maker of Cremona*. In 1909, she appeared in fifty-one films, blossoming into one of Hollywood's great women—movie star and producer, powerhouse in the boardroom, cofounder of United Artists and founding member of the Academy of Motion Picture Arts and Sciences. Her marriage to swashbuckling movie idol Douglas Fairbanks was the greatest Hollywood marriage of the silent movie era. Their handprints and signatures in concrete were the first in front of Grauman's Chinese Theatre. She shared the nickname "America's Sweetheart" with Shirley Temple.

Little Mary Pickford. Poster by Hennegan Co., Cincinnati, Ohio (1914). *Courtesy Library of Congress.*

JUNE 8, 1969: TOM AND DICK COMEDY

The Smothers Brothers Comedy Hour (1967–69), filmed in Los Angeles, aired its final episode. The CBS television network initially supported its experimental format, gambling on attracting a young, hip audience with satirical political sketches and popular music acts like Buffalo Springfield, Pete Seeger and the Who. Broadcast in the same time slot as the enormously popular *Bonanza*, the show tapped into the rebellious energy of the era and became hugely successful. But as Tom and Dick Smothers enjoyed creative freedom, their show grew increasingly controversial, repeatedly upsetting CBS executives to the point that the network broke its contract with the brothers and cancelled their show.

JUNE 9, 1909: ALICE'S ROAD TRIP

Alice Huyler Ramsey left New York, driving to San Francisco, the first woman to drive across the country. The twenty-two-year-old New Jersey housewife and mother traveled with her two older sisters-in-law and a sixteen-year-old female friend. She drove a four-cylinder, thirty-horsepower touring car 3,800 miles, reaching San Francisco on August 7. There were just 152 miles of paved roads, so they navigated with maps from the American Automobile Association and by following telephone poles. Ramsey had so much fun that she drove cross-county at least thirteen times until she said she lost count and fondly recalled the adventure of her first drive in *Veil, Duster and Tire Iron* (1961).

JUNE 10, 1967: SUMMER OF LOVE

The KFRC Fantasy Fair and Magic Mountain Music Festival, a musical gathering on Mount Tamalpais in Marin County, attracted some thirty-six thousand people, kicking off the Summer of Love. America's first rock festival, held the weekend before the Monterey Pop Festival, showcased some thirty bands, including the Doors, Canned Heat, Dionne Warwick, Country Joe and the Fish, Captain Beefheart, the Byrds and Jefferson Airplane. Stanley Mouse created the psychedelic poster for it, as he later famously did for Grateful Dead album jackets. Hells Angels provided a security detail, but there was no violence, unlike at the Altmont Free Concert (1969), which marked the end of an era that began on Mount Tamalpais.

JUNE 11, 1982: E.T. PHONE HOME

Filmed largely at a Culver City studio, Steven Spielberg's *E.T. the Extra-Terrestrial* debuted. It quickly became the highest-grossing film to date. The alien puppet was a masterpiece of blended movie magic. Its face is said to have been modeled on the features of Albert Einstein, Ernest Hemingway and Carl Sandburg, among other famous persons. E.T.'s voice reportedly blended the voices of eighteen actors. For its lifelike movement, a mime wore long, slender gloves that appeared like E.T.'s skin. Spielberg supposedly convinced six-year-old Drew Barrymore that the puppet was an actual alien.

JUNE 12, 1939: 3-D HORROR

Shooting began on *Dr. Cyclops*, the first horror film photographed in three-strip Technicolor by Paramount Pictures and the second sci-fi horror film in Technicolor, following *Mystery of the Wax Museum* (1933). Dr. Thorkel, a mad genius, summoned four explorers to Peru, but when they discover his use of radium to shrink creatures to one-fifth their normal size, they threaten to stop his experiments. He then turns his shrinking machine on them. The film, notable for its special effects, was directed by Ernest Schoedsack, also credited with *King Kong*.

JUNE 13, 1958: ZAPPA

The musician, songwriter, composer, record producer, actor and filmmaker named Frank Zappa graduated from Antelope Valley High School in Lancaster. The range and scope of his creativity, resulting in some sixty albums as leader of the Mothers of Invention, is unparalleled. Zappa went to high school with Don Van Vliet, later known as the musician Captain Beefheart.

JUNE 14, 1846: BEAR FLAG REVOLT

Thirty-three American rebels at the Sonoma plaza raised a flag decorated with a bear and a star, proclaiming the start of the Bear Flag Revolt and the California Republic. They unwittingly struck a blow in the Mexican-American War in California, as the United States had declared war against Mexico the month before. Around three weeks later, the California Republic ended when its militia joined the California Battalion under the command of U.S. Army brevet captain John C. Frémont. The Bear Flag was lowered over Sonoma when the Stars and Stripes was raised on July 9.

"Raising the Bear Flag," detail of a mural by Anton Refregier, Rincon Annex Post Office, San Francisco, California. Photograph by Carol M. Highsmith (2012). *Courtesy Library of Congress.*

JUNE 15, 2012: APPLE FOR SALE

A fully functioning Apple I computer originally priced at $666.66 in 1975 was sold at auction for $374,500. Steve Jobs had sold his VW Microbus and Steve Wozniak his calculator to pay for its parts and hand-built production costs. The Apple I is at the Nexon Computer Museum in Jeju City, South Korea, featured as part of a collection of sixty-six hundred items. It is the first permanent museum in Korea dedicated to the history of computers and video games.

JUNE 16, 1908: LA TAXIS

When taxicab service started in Los Angeles, a crowd gathered around one taxi parked in front of the Times building for an explanation of how the meter worked. Four passengers could ride for the same price as one. The cost from "any of the leading hotels to any of the theaters [was] 30 cents." A ride from downtown to the railway depot cost less than fifty cents. The city's ten Thomas Motor Car taxis, sixteen-horsepower vehicles, were the first west of Chicago.

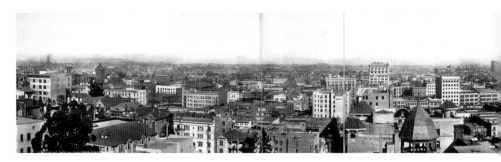

Los Angeles. Photograph by California Panorama Company, Los Angeles, California (circa 1908). *Courtesy Library of Congress.*

JUNE 17, 1890: A NEW CRIB

Lydia Mackenzie of San Francisco patented a portable crib. "My invention relates to an improvement in children's cribs; and it consists of a portable arrangement of parts." On the same day, Delia McGregory of Los Angeles patented a milk churn. "The object of my invention is to produce a wholesome, palatable, inexpensive compound, superior to my former compound in quality, texture, and appearance." Mackenzie and McGregory were among a host of women in nineteenth-century California who patented industrial and domestic innovations.

JUNE 18, 1903: HORATIO'S ROAD TRIP

Horatio Jackson accepted a bet that began the first transcontinental car trip from San Francisco. He bet fifty dollars that he could drive across the country, although he didn't own a car, had little driving experience and had no map. Jackson bought a used, two-cylinder, twenty-horsepower Winton automobile and convinced Sewall Crocker, a mechanic, to join him. They arrived in New York with their dog, Bud, on July 26, 1903. Ken Burns produced a documentary about their adventure, *Horatio's Drive* (2003).

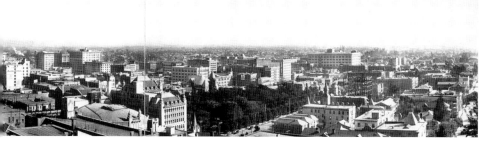

JUNE 19, 1855: PREMIER SPANISH PAPER

El Clamor Publico, California's first Spanish-language newspaper, began publishing in Los Angeles. It was founded by trilingual nineteen-year-old Francisco Ramirez, former Spanish editor of the *Los Angeles Star*. He filtered, synthesized and presented the news brought by ships and stagecoaches into a politically distinct, cultural journal. The paper ran weekly until August 1859.

Ed Sullivan. Photograph copyright Segriff Photos, Brackenridge, Pennsylvania (circa 1954). *Courtesy Library of Congress.*

JUNE 20, 1948: ED SULLIVAN

Toast of the Town, hosted by Ed Sullivan and filmed in Los Angeles, debuted on CBS-TV. The first prime-time variety show was later rebranded *The Ed Sullivan Show* (1955). It followed a vaudeville format, featuring singers, dancers, circus acts, puppets and monologuists. Sullivan welcomed a regular cast of characters and special guests, whose appearance on his show could make or break a career. Broadcast at the same time on Sundays until June 6, 1971, Sullivan's show was ritual viewing for the American family.

JUNE 21, 1989: RICKEY HENDERSON

The New York Yankees traded Rickey Henderson to the Oakland A's—during the season that the A's would win the World Series—for two pitchers and an outfielder. Henderson eventually played for the A's four different times, as well as for the Yankees, Blue Jays, Padres, Mets, Mariners and Red Sox. The left fielder, a member of the National Baseball Hall of Fame, was nicknamed the "Man of Steal." He is counted among the great leadoff hitters, baserunners and quotable baseball personalities. "If my uniform doesn't get dirty, I haven't done anything in the baseball game."

JUNE 22, 1849: A GOLD RUSH MUSICAL

Stephen Massett, Gold Rush entertainer, presented the first musical performance in San Francisco, where tents and shanties outnumbered wood buildings. His one-man show at the old Police Court in Portsmouth Square showcased the British poet-actor's gift for song and dance, original composition and sundry arts of a "wandering minstrel in many lands."

JUNE 23, 1849: GOLD RUSH NUGGETS

Two nuggets, one weighing 40 ounces and the other tipping the scale at 25 pounds, were found on the north fork of the American River, according to the Placer Times. The largest nugget found during the Gold Rush was dug up at Carson Hill above the Stanislaus River in 1854. It weighed 195 pounds and was valued at $43,534. In all, the Gold Rush yielded some 125 million troy ounces of gold worth more than $50 billion by today's standards.

JUNE 24, 1767: JESUITS GET BOOTED

Charles III, the Spanish king, expelled Jesuits from Alta California missions. He heard that they were hoarding gold, silver and pearls from the territory and not sharing with him, so he ordered them to return home. In fact, the

expulsion was part of a larger European political dynamic that involved Jesuit expulsions from the Portuguese empire, France, Poland, Lithuania and throughout the Spanish empire.

JUNE 25, 1978: GAY PRIDE FLAG

The rainbow flag representing gay pride flew for the first time in the San Francisco Gay Freedom Day Parade. Gilbert Baker's original design had colors removed, then re-included. Hot pink was removed because fabric that color was hard to find. Gilbert's design featured eight stripes, each color representing a specific meaning. The most common version has six stripes: red, orange, yellow, green, blue and violet. Baker passed away on March 31, 2017, in New York City at age sixty-five.

JUNE 26, 1925: LITTLE TRAMP

The Gold Rush, written, produced, directed by and starring Charlie Chaplin, premiered at Grauman's Egyptian Theatre in Hollywood. It tells the story of a brave weakling, played by Chaplin, seeking fame and fortune among sturdy men of the Klondike gold rush. A legendary scene shows him cooking a boiled boot and eating the shoelaces (black licorice was substituted for the laces). Chaplin reportedly shot the scene sixty-three times until he was satisfied. *The Gold Rush*, considered a masterpiece, is the fifth-highest-grossing silent film, earning more than $4,250,001 in 1926, nearly half of which went to Chaplin.

JUNE 27, 1542: SPANISH EXPLORERS

Juan Cabrillo sailed from Mexico for Alta California, the first European to chart those waters. His three ships left today's Acapulco searching for a northern sea route between the Pacific and Atlantic Oceans. He explored as far north as the Mendocino coast before returning south. The party sailed past the mouth of San Francisco Bay twice without noticing it. He anchored

at Santa Catalina Island to repair the ships in late November 1542. Around Christmas, Cabrillo fell onto a rock, shattering a bone while trying to rescue his men from attacking Tongva warriors and died of gangrene.

JUNE 28, 1846: BEAR FLAGGERS

An irregular U.S. military force commanded by Captain John Frémont, fresh from the Bear Flag revolt, shot and killed José de la Reyes Berryessa and brothers Francisco and Ramón de Haro, unarmed Mexicans who Frémont considered hostile, near the San Rafael mission. Kit Carson asked if he should take them prisoner. Frémont reportedly replied that there was no room for prisoners, so Carson killed the men and left them where they fell. Eyewitnesses gave conflicting accounts about almost every facet of the event. Did Frémont ordered the killings? Were Berryessa and the de Haros carrying secret messages? Nobody knows for sure.

JUNE 29, 2007: IPHONE RELEASE

When Apple Inc., in Cupertino, released the first iPhone, it began setting technology sales records literally overnight, beginning with 270,000 units sold during the first weekend. By the third quarter of 2010, it had sold 14.1 million units, a 91 percent increase over the third quarter of 2009. Apple had 4 percent of the cellphone market but earned more than 50 percent of the market profits. In January 2012, 53 percent of Apple's revenue came from selling iPhones. Apple's opening weekend sales for the 5C and 5S models marked all-time highs. Despite this, sales in the first quarter of 2016 declined 43.8 percent from the last quarter of 2015.

JUNE 30, 1864: FIRST STATE PARK

Yosemite Valley and its Mariposa Grove became California's first state park, the nation's first protected wild land, when President Abraham Lincoln signed the Yosemite Grant Act during the Civil War. His impetus is unclear,

Mirror Lake, Yosemite Valley. Steel engraving by Samuel Valentine Hunt after a painting by Harry Fenn. Published in *Picturesque America* by William Cullen Bryant. D. Appleton & Co., New York (circa 1872). *Courtesy Library of Congress*.

but he may have been inspired by writings of Thomas Starr King, the patriotic Unitarian clergyman. Carleton Watkins's mammoth photographs and Albert Bierstadt's dramatic paintings of Yosemite also may have inspired Lincoln's vision. Setting aside federal land for "public use, resort and recreation" represented a step toward a concept of the public good, part and parcel with the Homestead Act (1862), Morrill Land Grant College Act (1862) and the Freedman's Bureau Act (1865).

July

JULY 1, 1769: FATHER SERRA

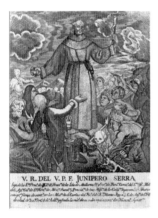

Father Junípero Serra, having marched nine hundred miles overland from Baja California with Gaspar de Portolà, reached San Diego. One of Portolà's supply ships, the *San Carlos*, at sea for nearly four months, overshot San Diego Bay by roughly two hundred miles before returning south. Its crew was so weak from scurvy that men on shore from another ship had to help the *San Carlos* crew ashore. It was a grueling journey by land or sea. About half of the men who started the trip died along the way.

Junípero Serra. Published in Francisco Palou's *Life and Apostolic Labors of the Venerable Father Junipero Serra, Founder of the Franciscan missions of California*. Introduction and notes by George Wharton James. G.W. James, Pasadena, California (1913). *Courtesy Library of Congress.*

JULY 2, 1982: "LAWN CHAIR LARRY"

Larry Walters, nicknamed "Lawn Chair Larry," flew an aluminum patio chair attached to forty-two helium-filled, eight-foot weather balloons to a height of sixteen thousand feet above San

Pedro. A surprised airline pilot radioed the airport control tower that he had passed a man with a gun flying in a lawn chair. The pellet gun was to shoot balloons for descent, but Walters dropped the gun, so he descended slowly until the balloon cables became tangled in a power line, causing a twenty-minute blackout in a Long Beach neighborhood. Walters was unhurt, paid a $1,500 penalty for violating air traffic rules and gave the chair to a neighborhood boy.

JULY 3, 1861: YOU'VE GOT MAIL

A Pony Express rider reached San Francisco with letters from St. Joseph, Missouri. Riders heading both east and west delivered mail in ten days, incredibly fast for the time. After nineteen months of service, it ended two days after the transcontinental telegraph reached Salt Lake City, which completed the link between Omaha, Nebraska, and Sacramento, California. The telegraph was an early example of technological innovation disrupting how things were done.

The overland Pony Express. A wood engraving from a painting by George M. Ottinger. *Harper's Weekly* (November 2, 1867). *Courtesy Library of Congress.*

JULY 4, 1846: DONNER PARTY PARTY

The Donner Party celebrated the patriotic holiday at Fort Laramie. Twelve-year-old Virginia Reed Murphy wrote about it in a letter to home. "We celebrated the 4 of July on plat at Bever crick, serveral of the gentemen in Springfield gave paw a botel of liker and said it shouden be opend till the 4 day of July and paw was to look to the east and drink it and they was to look to the West and drink it at 12 o clock paw treted the company and we all had some lemminade." Of the eighty-six people in the wagon train, forty-six survived the trek, including Virginia.

JULY 5, 1853: LOLA!

Lola Montez, self-styled Spanish dancer and Gold Rush femme fatale, performed her "Spider Dance" in Sacramento. It was considered erotic, prompting some communities to ban it. The *Sacramento Daily Union* reported, "Altogether so racy a night's entertainment has never been witnessed in Sacramento." Montez, also known as the Countess of Landsfeld, settled temporarily in Grass Valley, where she kept a tame grizzly bear and taught dancing lessons to the famous child actress Lotta Crabtree.

JULY 6, 1903: GEORGE'S ROAD TRIP

George Adams Wyman, the first person to cross the continent by motor vehicle, peddled his motor bicycle into New York City fifty-one days after he had left San Francisco. He found his way partly by following railroad tracks. Wyman was a competitive cyclist who had circumnavigated Australia on a bicycle. He was faster than Horatio Jackson, the first person to cross the continent by automobile (sixty-three days).

JULY 7, 1946: DAREDEVIL HUGHES

Howard Hughes crashed a prototype photographic reconnaissance airplane he was developing for the U.S. Army Air Force in a Beverly Hills

neighborhood. He attempted a crash landing at the Los Angeles Country Club golf course but clipped a series of houses, tearing the roof off one, demolishing a bedroom next door while the inhabitants were at home, wrecking a garage and taking out a row of trees before his plane burst into flames. Hughes was badly injured.

JULY 8, 1986: AEROBIE RECORD

Scott Zimmerman threw an Aerobie 1,257 feet at Fort Funston in San Francisco, setting a Guinness World Record for the "longest throw of an object without any velocity-aiding feature." He set a second record in 1988 by throwing an Aerobie across Niagara Falls. The Aerobie had been developed by Alan Adler, a Stanford professor, partly inspired by the Punjabi Chakram weapon. He sought to improve on the performance of Frisbees. Zimmerman's 1988 distance record finally fell when Erin Hemmings threw one 1,333 feet at Fort Funston on July 14, 2003.

JULY 9, 1846: END OF THE BEAR FLAG REPUBLIC

The three-week-old California Republic ended when a U.S. Navy lieutenant lowered a handmade flag featuring a grizzly bear, a single star and a stripe that had been flying over the Sonoma plaza and then raised the Stars and Stripes in its place. The events of the Mexican War, declared by Congress on May 13, 1846, had caught up with the premature, irregular insurrection led by John C. Frémont to free California from Mexico and annex it into the United States. The U.S. flag had already been raised over Monterey, the colonial capital of Mexican California, on July 7.

JULY 10, 1851: MOKELUMNE HILL

A U.S. post office opened at Mokelumne Hill, the Calaveras County town that was one of the richest during the Gold Rush. Some fifteen thousand people lived there—Americans, Frenchmen, Germans, Spaniards, Chileans,

Mexicans, Chinese and others. The ground was so rich that claims were just sixteen square feet, but many yielded as much as $20,000 in gold. Reportedly, a Frenchman hunting frogs for breakfast spotted a speck of gold that turned out to be a nugget that he sold for $2,150. For seventeen weeks in 1851, Mokelumne Hill witnessed at least one murder a week.

JULY 11, 2012: BANKRUPT SAN BERNARDINO

The San Bernardino City Council authorized filing under Chapter 9 federal bankruptcy law, making it the third California municipality to do so that year, after Stockton and Mammoth Lakes—the latter barely avoiding bankruptcy. San Bernardino reduced its police force, outsourced garbage collection and tried to transfer fire department expenses to the county. Neither it nor Stockton began to emerge from the crisis until 2015. They could not pay contracted CalPERS pension costs and looked to legal bankruptcy resolutions in Detroit, Michigan, for guidance.

JULY 12, 1949: "THE DUTCHMAN"

When the Los Angeles Rams signed Norm Van Brocklin, nicknamed "The Dutchman," they added a gifted quarterback to a team already led by a successful quarterback, Bob Waterfield. Coach Joe Stydahar played them both, platooning them for an average 38.8 points per game that season, setting an NFL scoring record. On opening night in 1951, Van Brocklin set another NFL record by passing for 554 yards. The Rams won the championship that year, the only time they did so while located in Los Angeles. Despite the fact that passing dominates NFL offenses today, no one has broken Van Broklin's 1951 yardage record.

JULY 13, 1923: HOLLYWOODLAND

The Hollywoodland sign, built as a massive real estate billboard, was officially dedicated on Mount Lee in the Hollywood Hills. Each letter was

thirty feet wide and about forty-three feet tall. The letters together were lit by four thousand bulbs at twenty watts each. The sign was designed to last eighteen months, but it grew into an iconic landmark. It was restored and then shortened to spell "Hollywood" in 1949. It is now protected by the Trust for Public Land.

JULY 14, 1934: CITYWIDE STRIKE

The San Francisco General Strike began in the violent aftermath of "Bloody Thursday," the violent zenith of the eighty-three-day West Coast Waterfront Strike. In a pitched battle with strikers on July 5, San Francisco police shot and killed 2 men, wounding 109 others. Some 65,000 trade unionists and many small businesses responded by staging the most widespread strike in U.S. history. They shut down the city for four days. In the end, all ports on the West Coast were unionized.

JULY 15, 1964: UNIVERSAL TOURS

Modern tours began at Universal Studios Hollywood, guiding visitors through dressing rooms, actual productions and staged events. The first tours in 1915, soon after Carl Laemmle opened Universal City, cost a nickel, including a chicken box lunch. Those tours stopped around 1930, because making movies with sound required a quiet set. The original Universal Studios, now enveloped by a theme park, provides an entertainment experience that's reproduced at Universal Studios Theme Parks in Florida and Japan.

JULY 16, 1769: SAN DIEGO MISSION

Father Junípero Serra dedicated Mission San Diego de Alcalá, built on ancient Kumeyaay land. It was the first of twenty-one Alta California missions located about a day's ride apart as far north as Sonoma. Kumeyaay resistance to the San Diego mission was relatively swift and

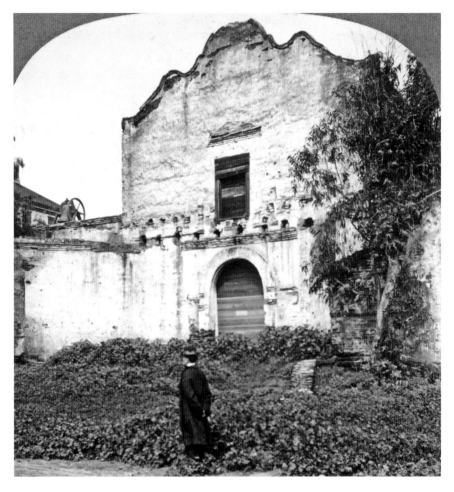

Mission San Diego. Stereograph by Keystone View Company, Meadville, Pennsylvania (circa 1915). *Courtesy Library of Congress.*

persistent. They did not welcome the intrusion, attacking the settlement within a month. Resistance peaked in 1775, when some seven hundred warriors set fire to the mission and killed Father Luís Jayme. It was one of a dozen major rebellions by Native Americans during the mission period.

JULY 17, 1944: PORT CHICAGO DISASTER

Munitions being loaded onto a cargo vessel bound for the Pacific theater exploded at Port Chicago Naval Magazine near Concord, killing 320 sailors and civilians and wounding 390. It was the largest loss of life on the home front during World War II. Most casualties were African American. In response to ongoing unsafe conditions, hundreds of servicemen refused to load munitions in what was called the Port Chicago Mutiny. Fifty protestors were charged and tried. Safety measures were improved, but the disaster at a predominantly African American U.S. Navy installation had the unintended consequence of spurring integration within the U.S. armed forces.

JULY 18, 1968: INTEL

Gordon Moore and Robert Noyce founded Intel Corporation in Mountain View. They had recently left Fairchild Semiconductor, the wellspring of what became Silicon Valley. Intel distinguished itself by making semiconductors, dominating the market for personal computer processors and branding itself with an "Intel Inside" marketing campaign. Recent growth targets include the world of wearable fashion. Headquartered in Santa Clara, Intel is one of the world's largest and highest-valued semiconductor chip manufacturers.

JULY 19, 1963: BOMB OOPS

The U.S. Navy accidentally dropped a two-foot, twenty-five-pound practice bomb on Market Street in San Francisco. It struck the street, bounced over a seven-story corner building, smashed concrete and shattered windows before falling onto the next street, which was crowded with lunch-hour pedestrians. Amazingly, nobody was hurt.

JULY 20, 1940: LA FREEWAYS

Arroyo Seco Parkway, the first freeway in the western United States, opened a 3.7-mile section between Pasadena and Los Angeles. It followed

Arroyo Seco Parkway seen from Arroyo Boulevard bridge. Note road cut in South Pasadena and the Grand Avenue Bridge in the distance (no date). *Courtesy Library of Congress.*

a creek bed used by wagons when the creek was dry. The phrase *arroyo seco* means "dry gulch." In 1900, the California Cycleway Company built an elevated wooden bikeway along the route between the cities. The natural avenue that became Arroyo Seco Parkway, then the Pasadena Freeway, and later incorporated into State Route 110, represented a compromise between City Beautiful advocates and the influential Automobile Club of Southern California.

JULY 21, 1952: KERN COUNTY QUAKE

The Kern County earthquake struck in the southern San Joaquin Valley, killing twelve people, injuring hundreds and causing some $60 million in property damage, including many buildings in Tehachapi. Bakersfield never looked the same after losing its architectural landmarks. The 7.3 temblor, the third largest in California history, unleashed one hundred times the energy of the 1933 Long Beach earthquake and was felt from San Francisco to San Diego to Las Vegas. Landslides across roadways and collapsed railroad tunnels hampered relief efforts.

JULY 22, 1916: TERRORISM

A suitcase bomb exploded at the San Francisco Preparedness Day Parade, killing ten people and injuring forty in the deadliest attack in the city's history. The parade, in support of America's entry into World War I, was opposed by antiwar activists who threatened a violent protest. Thomas Mooney and Warren Billings, prominent radical labor leaders, were arrested, tried and found guilty. Years later, a review commission found no proof of their guilt but discovered false testimony against the men, who were pardoned and released.

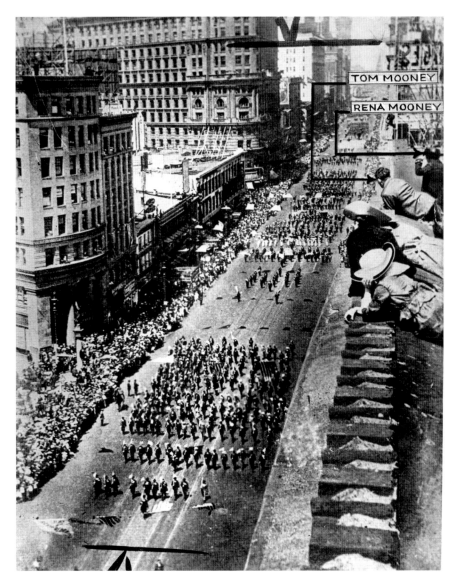

Preparedness Day Parade looking down Market Street toward the Ferry Building in San Francisco, California. Tom Mooney and wife are on the rooftop indicated by arrows. Mooney claimed he was on this roof when the bomb exploded. Photograph copyright Pacific & Atlantic Photos, Incorporate (July 22, 1916). *Courtesy Library of Congress.*

JULY 23, 1849: TRIAL OF THE HOUNDS

In the trial of the Hounds, one of San Francisco's first criminal prosecutions, some twenty members of a racist gang were found guilty of rioting, robbing and assaulting Chileans, Peruvians and Mexicans in the city with intent to kill. Hounds had terrorized the town, which did not yet have a police force, for months before their wanton attack on the Hispanic community spurred people to turn out in their defense. But the demise of the Hounds hardly reined in criminal activity until the rise of the San Francisco Committee of Vigilance in 1851 and 1856.

JULY 24, 1929: BUNION DERBY

The second Trans-American Footrace from New York to Los Angeles ended after two and a half months. Among the runners of what was called the Bunion Derby was sixty-year-old Harry Abrams, who had run the nearly thirty-five-hundred-mile race in 1928, the first known person to run across the continental United States twice. Runners averaged about sixty miles per day for nearly eighty days.

JULY 25, 1896: CRITICAL MASS

Some 5,000 cyclists took to the streets of San Francisco to demonstrate for better roads, resurfaced cobblestone streets and protections against rail tracks and streetcar slots. The event, part of a nationwide cycling movement, included clubs like the Bay City Wheelmen, YMCA Cyclers and Pathfinders Alpha Ladies' Cycling Club. The Colored Cycle Club of Oakland was excluded, but people of all races rode, many in costumes, like the man "in the togs of a Midway Plaisance maiden." Just over a century later, on July 25, 1997, another 5,000 cyclists rode through San Francisco in an event called Critical Mass, protesting for road safety. Police arrested about 250 riders for traffic violations.

JULY 26, 1860: EMPEROR NORTON

Norton I, self-appointed Emperor of North America and Protector of Mexico, issued a royal proclamation dissolving the United States. San Francisco's celebrated eccentric issued other royal decrees, including one commanding a bridge be built where the Oakland Bay Bridge now stands, leading some to contend it should be renamed in his honor. The Gold Rush city so embraced Emperor Norton's theatrics that he issued his own money, ate and drank for free at restaurants and enjoyed a private box at the theater. His fame even extended to his dogs, Bummer and Lazarus.

JULY 27, 1846: DONNER PARTY MISTAKE

The Donner Party reached Fort Bridger on their doomed overland journey to California in which half would die and others survive by cannibalism. They rested for four days at the corral and cabins of Jim Bridger, fur trader, where they learned that Lansford Hastings, their guide, had left instructions to follow him. Leaving the fort, they struggled to follow Hastings's shortcut and were forced to carve a road through forests and boulder fields, fell behind schedule to cross the Sierra Nevada before winter and then became snowbound near the summit until spring.

JULY 28, 1938: FLYING BOAT MYSTERY

The Hawaii Clipper airplane, a luxurious pontooned "flying boat," disappeared mysteriously over the Pacific between Guam and Manila with six passengers and nine crew. It was completing the last leg of a six-day, sixty-hour flight from San Francisco Bay with stops in Hawaii, Midway and Guam. No trace of it has ever been found. Some say the airship was hijacked.

JULY 29, 1914: HELLO?

Alexander Graham Bell, in New York, made a test transcontinental phone call to Dr. Thomas Watson in San Francisco. The last pole had been erected and the line completed on July 27, but commercial service didn't start for six months to allow AT&T to promote it at the Panama-Pacific International Exposition in 1915. Bell repeated his famous request, "Mr. Watson—come here—I want to see you." Watson replied, "It will take me five days to get there now!"

Charlotte Gillard of San Francisco. "Child's table tray." U.S. patent number 208,807. *Courtesy U.S. Patent and Trademark Office.*

JULY 30, 1877: IMPROVED TABLE TRAY

Charlotte Gillard of San Francisco patented a child's table tray. "The advantages of my device lie principally in its simplicity and its great durability. It can also be attached to or removed from a table very easily, and will be held rigidly when placed in position." Without much information on the life of the inventor or the history of children's furniture, one can only wonder how this patent came to be. There was a group of women inventors in San Francisco in the 1870s. Did they know of and support one another in their creations and filings for patents?

UFW boycott lettuce. Silkscreen poster (1972). *Courtesy Library of Congress.*

JULY 31, 1979: FARMWORKER STRIKE

Cesar Chavez, civil rights activist, began a twelve-day march leading members of the United Farm Workers (UFW) from San Francisco to Salinas to draw attention to their six-month strike against California lettuce growers. He called for a boycott against Chiquita bananas, A&W root beer and Morrell

meats, all owned by United Brands, which owned the largest lettuce farms in Salinas. The UFW successfully won a significant pay raise for farmworkers and other contract improvements. Chavez's birthday, March 31, is celebrated as a state holiday in California, Colorado and Texas.

August

AUGUST 1, 1852: AME ZION CHURCH

Reverend John Jamison Moore established the First African Methodist Episcopal Zion Church in San Francisco. Born into slavery in West Virginia, John and his mother fled to freedom. She instilled in John a passion for fighting for the rights of his people. Reverend Moore was not only the first pastor of his San Francisco church, he served as a teacher and principal at the San Francisco Colored School. Today, the AME Zion Church remains actively involved in the community and delivers a message of "wholeness of self" to a congregation that has included Sojourner Truth, Harriet Tubman and Frederick Douglass.

AUGUST 2, 1847: PRE—GOLD RUSH STEAMBOAT

William Leidesdorff launched the first steamboat in San Francisco Bay. The *Sitka*, a thirty-seven-foot-long bark, had been built as a pleasure craft for the Russian-American Company in Alaska. Leidesdorff initially used it that way, for excursions around the bay, then steaming up the Sacramento River. His little steamboat sank a year later, was re-floated and its engine removed, then put to work grinding coffee. The boat was rigged as a sailboat. Leidesdorff

was among the first mixed-race U.S. citizens in California. In addition to his business enterprises, he served as the San Francisco treasurer and school board president. His estate was valued at around $1,445,000 in 1856, not including the gold mined from his land.

AUGUST 3, 1908: ALLENSWORTH

Colonel Allen Allensworth filed site plans for the town of Allensworth, some thirty miles north of Bakersfield in the San Joaquin Valley. He envisioned it as an African American town where people could live free of racism. Although born into slavery, Allensworth escaped and became a Union soldier, Baptist minister and educator. His town, the only such place in California, thrived for nearly a decade until the Santa Fe Railroad moved its station from Allensworth to Alpaugh and the drinking water became toxic as water levels fell. His accidental death led to the unraveling of his town but not his dream. Allensworth today is a California State Historic Park.

AUGUST 4, 1969: DODGER STADIUM HOMERS

Willie Stargell of the Pittsburgh Pirates hit the first home run out of Dodger Stadium. At 506 feet, 6 inches, it is still the longest homer at the park by 23 feet. Stargell hit another ball out of the park in 1973. Just three other batters have hit home runs out of Dodger Stadium (Giancarlo Stanton, Mike Piazza and Mark McGwire), but no one else has done it twice.

AUGUST 5, 1775: EUROPEANS IN SAN FRANCISCO BAY

Juan de Ayala captained the *San Carlos* as the first European ship sailed into San Francisco Bay. For some two hundred years, explorers had sailed past the Golden Gate, often cloaked in fog, without recognizing it for what it is. Members of Gaspar de Portolá's land expedition, which got lost while searching for Monterey Bay, were the first Europeans to see it, in 1769.

Ayala's *San Carlos* anchored near Angel Island. While the wounded captain stayed aboard, his pilots spent forty-five days charting the bay before returning to Mexico.

AUGUST 6, 1846: DONNER PARTY LOST

The Donner Party, the doomed wagon train, stopped at the mouth of Weber Canyon. The travelers had tragically chosen to follow Lansford Hastings, who left them a note warning that his ostensible shortcut, the Hastings Cutoff, was impassable and that they needed to send someone ahead for instructions. James Reed and two others set out to follow Hastings's wagon tracks. They returned four days later with fresh instructions directing them toward an uncharted path through forests and boulder fields. This was a tragic mistake.

AUGUST 7, 1970: COURTHOUSE SHOOTOUT

In an attempt to free his brother George Jackson and other Black Panther inmates from Soledad Prison, seventeen-year-old Jonathan Jackson smuggled guns into a Marin County courthouse with a plan to kidnap and ransom Superior Court judge Harold Haley for their freedom. Jackson, Judge Haley and two others died in the resulting gunfight, and two others were wounded. Angela Davis, fired radical UCLA professor and George Jackson's lover, was implicated in the plot. She fled but was arrested, then tried and eventually found not guilty of conspiracy, kidnapping and homicide.

AUGUST 8, 1958: "TOM DOOLEY"

The Kingston Trio, which started as a San Francisco nightclub act, released "Tom Dooley," a folk song based on a nineteenth-century murder in North Carolina. The 45rpm record topped the Billboard chart by late November, sold one million copies by Christmas and reportedly sold more than six million copies altogether. Its popularity is often credited with starting the

folk music boom of the late 1950s and 1960s and the worldwide interest in American roots music that continues today. The Grammy Foundation named "Tom Dooley" one of its songs of the century.

AUGUST 9, 1969: MANSON MURDERS

At his direction, four members of Charles Manson's "family" killed the pregnant actress Sharon Tate and four friends at a home in Los Angeles. Then, over the following five weeks, they committed nine additional murders at four locations. The sensational, seemingly random killings accompanied by inflammatory statements written in the victims' blood terrified the nation.

AUGUST 10, 1932: RIN TIN TIN

Hollywood canine movie star Rin Tin Tin, rescued as a puppy from a World War I battlefield, died. He appeared in twenty-seven films and received more than ten thousand fan letters a week. He even may have received the most votes for the first Academy Award for Best Actor (1929), but the academy decided a human should win.

AUGUST 11, 1965: WATTS RIOTS

Riots begin in the Watts neighborhood of South Los Angeles, sparked by a California Highway Patrol arrest of a black motorist that turned violent. Violence raged for six days. Some fourteen thousand California National Guard troops were mobilized to quell the neighborhood. Thirty-four people died, more than one thousand were injured and nearly four thousand arrested. Property damage exceeded $40 million. The Watts riots, also called an insurrection, became a turning point in the American civil rights movement. The neighborhood, however, continues to suffer from high unemployment, substandard housing and inadequate schools.

AUGUST 12, 1977: SPACE SHUTTLE

Enterprise, the first orbiter of the Space Shuttle program, flew independently for the first time. It took off from the top of a Boeing 747 and landed at Edwards Air Force Base. The orbiter was originally to be named *Constitution*, but *Star Trek* fans started a write-in campaign to name it *Enterprise*, after the ship in the television series. The test vehicle, which is not equipped for space flight, is on display at the Smithsonian's National Air and Space Museum in Washington, D.C.

AUGUST 13, 1846: WAR WITH MEXICO

The American flag was raised for the first time over Pueblo de Los Angeles, essentially ending the Mexican-American War in Alta California. But harsh martial law imposed by U.S. forces ignited an uprising among Californios starting on September 22, 1846. The Siege of Los Angeles temporarily drove U.S. forces from the town. They retreated to Fort Hill but had no water, so they surrendered then retreated from LA aboard the American merchant vessel *Vandalia*.

AUGUST 14, 1850: SQUATTER RIOTS

Land-grabbing squatters rioted in the newly formed town of Sacramento City. Violence erupted between the newcomers and men who claimed to own the land along the Sacramento River, where the city was growing. Land grabs like this were common, because Mexican land deeds, like John Sutter's, were disputed by the 49ers.

AUGUST 15, 1939: OZ

After a sneak preview in San Bernardino, *The Wizard of Oz* premiered at Grauman's Chinese Theatre in Los Angeles. The film met with critical acclaim but only moderate box office success, not showing what MGM

Fred R. Hamlin's musical extravaganza *The Wizard of Oz*. Lithograph poster. U.S. Lithograph Company, Cincinnati, Ohio, and New York (circa 1903). *Courtesy Library of Congress*.

considered a profit until a 1949 re-release. Today, it is one of the most beloved films and part of popular culture. The first book in the Oz series, published in 1900, has been adapted many times for film, television, theater, books, comics, games and other media.

AUGUST 16, 1927: DOLE AIR RACE

The Dole Air Race, the first from Oakland to Honolulu, began. It was a tragic affair. Eleven airplanes were certified to compete, but three crashed before the race began, killing their pilots. Of the remaining eight planes, two crashed during takeoff and two disappeared over the Pacific. A third plane returned to Oakland for repairs then took off again to search for the missing planes, but it also disappeared. Ten lives and six airplanes were lost. Two planes landed in Hawaii. A sturdy little plane named *Woolaroc* won the race with a flying time of twenty-six hours, seventeen minutes.

AUGUST 17, 1953: NA

Narcotics Anonymous, cofounded by Kimmy Kinnon in Los Angeles, was modeled on the Alcoholics Anonymous twelve-step program. At first, NA was not generally viewed positively, and its founders often met in homes because public spaces did not welcome them. Members feared the police would raid their meetings. It took years for NA to be respected as a constructive organization. In 1970, there were only twenty regular weekly meetings, all in the United States. Forty years later, there were NA meetings in more than 130 countries.

AUGUST 18, 1947: HP

Hewlett-Packard Company, in Palo Alto, was incorporated. It initially produced a precision audio oscillator to design, produce and maintain audio equipment. HP reported first-year revenues of $1.5 million and grew to become the world's leading personal computer manufacturers by 2007. On

August 18, 2011, it announced that it would stop manufacturing personal computers, smart phones and tablet computers to focus on "strategic priorities of Cloud solutions and software with an emphasis on enterprise, commercial and government markets."

AUGUST 19, 1964: BEATLES IN SF

Six months after taking the East Coast by storm, the Beatles played at the Cow Palace in San Francisco, launching their first U.S. concert tour. Dress circle tickets cost $6.50. Gate receipts totaled $91,670.00. Their share was $47,600.00 gross. The band played just twenty-nine minutes, stopping twice because of jellybeans thrown onto the stage. Nineteen girls required first aid, and one boy dislocated his shoulder; fifty fans were hurt, and two were arrested. The Beatles returned to the Cow Palace once more on August 31, 1965.

AUGUST 20, 2012: APPLE VALUE

The price of a share of Apple Corp., in Cupertino, closed at $662.38. That made its value $623 billion, the world's highest market cap in history. By February 11, 2015, a share of Apple stock rose 23,639 percent from its first trading day. It closed at $710.8 billion in value, more than twice the value of Microsoft. Apple's best trading session was August 6, 1997, when the stock rose 33.3 percent. Its worst was on September 29, 2000, when the stock fell 51.90 percent. At one time, it held more than $250 billion in cash reserves.

AUGUST 21, 1935: BENNY GOODMAN SWINGS

Benny Goodman and his band launched the swing era in a series of shows at the Palomar Ballroom in Los Angeles. Goodman's radio broadcasts at midnight from New York found a young West Coast prime-time following hungry for his hot Fletcher Henderson arrangements. When the radio show folded, the band went on tour, mostly playing traditional big band standard

Benny Goodman. Photograph by C.M. Stieglitz for World Telegram, New York (between 1932 and 1938). *Courtesy Library of Congress.*

arrangements. It struggled financially and nearly went broke by the time it reached California. The band opened with the usual standards, nearly lost the audience at the Palomar Ballroom and then decided that if it were going to go broke, it would go broke playing what it loved.

AUGUST 22, 2008: OUTSIDE LANDS

The first Outside Lands rock festival opened in San Francisco's Golden Gate Park to a crowd of some sixty thousand. It featured over sixty musical acts from around the world, including Radiohead, Beck, Manu Chao and the Black Keys. These days, the festival promotes food, wine and art in addition to music. The eco-friendly event utilizes solar power stages, refillable water, waste diversion, recycling and valet parking for bicycles. Outside Lands was a nineteenth-century term for today's Richmond and Sunset Districts in San Francisco. The area's large sand dunes were considered uninhabitable, but it now includes Golden Gate Park, Ocean Beach and neighborhoods.

AUGUST 23, 1970: SALAD BOWL STRIKE

Cesar Chavez, head of the United Farm Workers (UFW), called a strike against the Teamsters Union, which had been granted jurisdiction to organize fieldworkers hired by California lettuce growers. Some five thousand to seven thousand fieldworkers walked off the job, doubling the price of lettuce nearly overnight and costing growers around $500,000 a day. The courts ordered Chavez and the UFW not to picket, but it did. The UFW then called for a nationwide boycott. The Salad Bowl Strike, the largest farmworker strike in U.S. history, ultimately led to passage of the California Agricultural Labor Relations Act (1975).

AUGUST 24, 1932: AMELIA EARHART

Amelia Mary Earhart flew from Los Angeles, California, to Newark, New Jersey, covering 2,448 miles in nineteen hours and five minutes to become the first woman to fly nonstop across the United States. This followed Earhart's solo, nonstop flight across the Atlantic, which made her the second person after Charles Lindbergh and the first woman to do so. Earhart continued setting aviation records for speed and endurance, including for flights from Hawaii to California and from California to Mexico. In 1937, she launched her around-the-world flight, logging 22,000 miles before she disappeared.

AUGUST 25, 1929: GRAF ZEPPELIN

On its voyage around the world, *Graf Zeppelin* passed over San Francisco after crossing the Pacific Ocean en route to Los Angeles, where it landed the next day. The event caused a public sensation. During its nine years of service, the German airship, 787 feet long and 115 feet high, flew more than one million miles on 590 flights, carrying more than thirty-four thousand passengers without a single injury. It accomplished the first commercial transatlantic passenger flight, the first commercial passenger flight around the world and flew a scientific mission over the North Pole.

AUGUST 26, 2009: THREE MAJOR FIRES

This date marks the worst day for fires in California history. In 2009, the Station Fire grew into the largest wildfire in Los Angeles County history. Two firefighters died battling the 230-square-mile blaze, which destroyed 209 structures, including 89 homes. The same day, the Big Meadow Fire burned 12 square miles inside Yosemite National Park. It was not fully contained until September 10. Then, on August 26, 2013, the Rim Fire grew to 150,000 acres on the western edge of Yosemite National Park. It began on August 17 and eventually covered over 250 square miles.

AUGUST 27, 1913: ARCADE STABLES FIRE

A fire at the Arcade Stables on Folsom Street in downtown San Francisco killed ninety-five horses. The same year, the last of the city's horse-drawn streetcars was retired and replaced by United Railways Company electric cars, that had been introduced twenty years earlier.

AUGUST 28, 1863: KONCOW TRAIL OF TEARS

In reaction to the murder of local settlers, all Koncow Maidus living near Tidwell Ranch, near today's Chico, were forced from their homes, rounded up and marched under guard to Round Valley Reservation. Orders were to shoot any Indian who remained in the area. Then, 461 people began the one-hundred-mile march in what became known as the Koncow Trail of Tears. Only 277 people survived. Mothers reportedly tried to kill their babies, fearing they would be abandoned along the trail if the mothers died. You can hike a four-mile section of the Nome Cult Mountain House Trail in the Mendocino National Forest.

A Maidu man. Photograph by Edward S. Curtis (circa 1924). In *The North American Indian* by Edward S. Curtis. Seattle, Washington (1907–30), volume 14. *Courtesy Library of Congress.*

AUGUST 29, 1911: ISHI

The last of his Yahi people, a man later named Ishi, was found starving, disoriented and cowering in a chicken coop near Oroville. His world had been devastated by development and his people hunted and killed. He spoke a language understood by no one else. UC Berkeley anthropologists became his protectors. They studied, befriended and hired him as a research assistant. Ishi lived for five years in San Francisco, graciously demonstrating his traditional way of life. The Ishi Wilderness Area in northeastern California, his ancestral grounds, is named in his memory.

AUGUST 30, 2012: CURRY VILLAGE

Following six infections and two deaths from hantavirus, Yosemite National Park closed the Curry Village tent cabins. The cabins, built to replace those removed after the 2008 rock fall, had been constructed with insulated double walls, but they became home to the deer mice that carried the disease. Some ten thousand visitors were potentially at risk; eight cases were identified, and three people died by early September 2013. The campground had been established by David and Jenny Etta Foster Curry, called "Mother Curry," in 1899. They provided "a good bed and clean napkin with every meal" for two dollars a day.

AUGUST 31, 2009: THE IRON MOUSE

The Walt Disney Company, headquartered in Burbank, announced plans to buy Marvel Entertainment Inc. for $4 billion. That brought Iron Man and Spider-Man along with five thousand other Marvel characters into the family with Mickey Mouse, Buzz Lightyear and Luke Skywalker. The deal was complicated by Marvel's contracts with 20th Century Fox, Columbia Pictures and Universal Parks & Resorts. Disney turned a profit on the purchase. Its stock price rose from $26 to over $100, and Marvel-related box office revenues from movie and TV shows surpassed $8 billion, easily covering the original purchase price.

Walt Disney with a Mickey Mouse drawing. Photograph by Harris & Ewing (1931). *Courtesy Library of Congress.*

September

SEPTEMBER 1, 1979: HE RODE AGAIN

A Los Angeles court ordered Clayton Moore to stop wearing his Lone Ranger mask. For years after the run of the TV show in which Moore starred, *The Lone Ranger* (1949–57), he made commercial appearances in character wearing his costume. Following the court order, he replaced the mask with similar-looking sunglasses, then countersued and won the right to wear his original Lone Ranger outfit.

Kickerz Coffee drive-through in Tyler, Texas, adapted the Lone Ranger hat, mask and other aspect in imaginative architecture. Photograph by Carol M. Highsmith (May 18, 2014). *Courtesy Library of Congress.*

SEPTEMBER 2, 1797: MISSION CHRISTENING

The first Indian baptized at Mission San Jose was a twenty-four-year-old woman christened "Josefa"; her name was initially recorded as Gilpae de los Palos Colorados, suggesting that she had lived in the redwood forest area around modern-day San Leandro. Mission San Jose still performs the Sacrament of Baptism.

SEPTEMBER 3, 1995: EBAY'S BIRTHDAY

The website eBay, originally called AuctionWeb, was founded in Pierre Omidyar's San Jose living room. The first item it sold was a broken laser pointer. While still headquartered in San Jose, it became one of the nation's fastest-growing companies. It is now a multibillion-dollar enterprise conducting transactions in over 180 countries.

SEPTEMBER 4, 1781: LA'S BIRTHDAY

Mexican provincial governor Felipe de Neve, forty-four settlers and soldiers and two padres at San Gabriel Mission founded El Pueblo de la Reyna de los Angeles, today known as Los Angeles. The community was made up of eleven families with twenty-two children. Twenty-six settlers had African ancestry.

SEPTEMBER 5, 1878: A FIRST FOR WOMEN

Clara Foltz passed the University of California bar exam to become the first female lawyer on the West Coast. She and Laura de Force Gordon applied to Hastings College of the Law but were denied admission because of their gender. Foltz and Gordon sued, argued their own case and won admission. In 2002, the Criminal Courts Building in downtown Los Angeles was renamed the Clara Shortridge Folz Criminal Justice Center. Gordon became a leader for women's rights and, as editor of the *Stockton Daily Leader*, became the first woman in the nation to run a daily newspaper.

SEPTEMBER 6, 2005: LGBT RIGHTS

The California legislature approved same-sex marriages, but Governor Arnold Schwarzenegger vetoed the bill. Dozens of same-sex couples had gotten married following San Francisco mayor Gavin Newsom's instructions to city officials in 2004. The California Supreme Court then ruled that Newsom had overstepped his authority. In 2007, Schwarzenegger vetoed a state law to legalize gay marriage; it went back to the courts, became an election proposition and then was contested. Same-sex marriage rights in California were established in 2013.

A man looking at a television receiver. Photograph by Keystone View Company, Studios, Meadville, Pennsylvania (circa 1930). *Courtesy Library of Congress.*

SEPTEMBER 7, 1927: TV BEGINS

Philo Farnsworth, age twenty-one, transmitted an image through purely electronic means with a device called an image dissector in his San Francisco laboratory. That accomplishment was the beginning of television technology. RCA tried to buy his invention for $100,000, but he turned it down.

SEPTEMBER 8, 1923: NAVAL DISASTER

Seven U.S Navy vessels wrecked on Honda Point on the Santa Barbara County coast, killing twenty-three sailors. The spot, nicknamed the "Devil's Jaw," is one of the windiest on the Pacific coast and famously treacherous to navigate. A squadron of seventeen ships practicing maneuvers failed to take adequate readings, leading to the largest peacetime loss of navy ships in U.S. history.

SEPTEMBER 9, 1850: ADMISSION DAY

California became the nation's thirty-first state as part of the Compromise of 1850, which balanced the number of states where slavery was legal with

those where it was not. The state's capital, meanwhile, moved from San Jose to Vallejo and then Benicia before shifting to Sacramento, then briefly to San Francisco after the Sacramento capital burned. The capital was finally moved back to Sacramento. Also in flux, Admission Day was a state holiday, then had its status revoked in 1984 before being legally reinstated.

SEPTEMBER 10, 1887: POMONA LIBRARY

Pomona Public Library started with four hundred books in a room of a building at Third and Main Streets. It was open for business two days a week from 2:00 p.m. to 5:00 p.m. At the time, people paid a membership fee and dues of three dollars for borrowing privileges. Today, Pomona Public Library is an essential resource for materials and programs serving its community.

SEPTEMBER 11, 1812: RUSSIANS IN AMERICA

The Russian-American Company established a fort on the Sonoma coast. The spot was selected because it was a rich sea otter hunting ground—the animal was a commodity traded with China. The area also was fertile enough to grow wheat and other crops for the company's Alaskan colonies and was strategically located for trade with Spanish California. Ultimately, the company's efforts failed; in December 1841, it was sold to John Sutter, who promised payment but never followed through. Today, Fort Ross is a California State Historic Park.

SEPTEMBER 12, 1910: ANOTHER FIRST FOR WOMEN

Alice Stebbins Wells became the first policewoman in the country when the Los Angeles Police Department swore her in. The married mother of two children was given a badge, assigned a telephone call box, handed a rule book and a first aid book but not issued a gun. She worked with the city's first juvenile officer, was tasked with questioning young female suspects and patrolled skating rinks and dance halls as well as interacting with female

members of the public. Two years after joining the LAPD, she founded the International Policewomen's Association and traveled widely to advocate for female officers.

SEPTEMBER 13, 1791: PLANTING A YANKEE

John Graham became the first U.S. citizen buried in Alta California. All that's known about him is that he joined Alejandro Malaspina's scientific global marine expedition in Spain in 1789. Graham died at sea and, for unknown reasons, was brought ashore at Monterey and buried in the Royal Presidio, although that was against the law.

SEPTEMBER 14, 1786: FRENCH VISITORS

The French ships *La Boussole* and *l'Astrolabe* anchored in Monterey Bay for a ten-day visit. They were part of European naval expeditions exploring and laying claim to territory around the world. After hoisting anchor, they sailed west, but neither completed its mission, as both were wrecked and sank in a South Pacific storm.

SEPTEMBER 15, 1858: YOU'VE GOT MAIL

Butterfield Overland Mail service began twice-weekly, year-round mail service. Delivery from St. Louis, Missouri, to San Francisco took twenty-five days, amazingly fast for the time. The company's motto was "Remember, boys, nothing on God's earth must stop the United States mail!" The San Antonio–San Diego Mail Line, the first stagecoach and mail operation to California, was fondly called the "Jackass Mail."

SEPTEMBER 16, 1810: RANCHO ERA

The Mexican War of Independence from Spain began when Miguel Hidalgo y Costilla, a revolutionary Catholic priest, issued the "Grito de Dolores" urging his countrymen to fight for freedom from three hundred years of colonial rule. They fought for redistribution of land and racial equality, the war lasting until 1821, when victory marked the beginning of the rancho era in Alta California.

SEPTEMBER 17, 1895: BABY WALKER

Sesi Kell of Los Angeles patented a baby walker. "The object of my invention is to provide a device of this class which will support the child in an upright position and guide it in a circular course, when desired, and which, when it is desired to allow the child to rest, can quickly be arranged to seat the child with a play-table surrounding it."

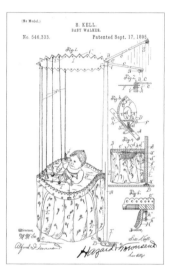

Sesi Kell of Los Angeles. "Baby walker." U.S. patent number 546,333. *Courtesy U.S. Patent and Trademark Office.*

SEPTEMBER 18, 1975: HEIRESS ON THE RUN

Patty Hearst was arrested after a year on the FBI's Most Wanted List. The nineteen-year-old heiress of a powerful and political newspaper family was kidnapped from her Berkeley apartment by the Symbionese Liberation Army, which considered itself a vanguard of an American revolution. She was brainwashed and then joined the group's members in a bank robbery. Following her capture, Hearst was tried, found guilty and imprisoned for almost two years before President Jimmy Carter commuted her sentence.

SEPTEMBER 19, 1957: BIRTH OF THE VALLEY

Eight engineers formed the Fairchild Semiconductor in Santa Clara. The "Fairchild Eight" became the principal pioneers of the computer industry, founding companies like Intel and Hewlett-Packard. It's said that some four hundred companies can be traced to these men, who began developing and mass-producing transistors and other semiconductor devices. They shipped their first sale of one hundred transistors to IBM in a re-purposed Brillo carton because they hadn't developed their own packaging yet.

SEPTEMBER 20, 2005: MONARCHS RULE!

The Sacramento Monarchs won their first Women's National Basketball Association championship, defeating the Connecticut Sun in game four of the WNBA finals, 62–59. Yolanda Griffith collected 14 points and had ten rebounds and was unanimously voted the series MVP for averaging 18.5 points and ten rebounds per game.

SEPTEMBER 21, 1769: EIGHTEENTH-CENTURY CAMPING

Gaspar de Portolá camped west of the Nacimiento River. He and his men were searching for Monterey to establish a colony there. Portolá, sixty-three leather-jacket soldiers and one hundred mules loaded with provisions had been marching north from Mexico since July 14. One of the men wrote in his diary, "We rested at this place so as to give time for the scouts to examine the country carefully, and also to allow the animals to recuperate somewhat, as they were in bad condition." They overshot Monterey Bay but found San Francisco Bay.

SEPTEMBER 22, 1880: BANDIT POET STRIKES AGAIN

Charles Earl Boles, the English-born gentleman bandit known as Black Bart, left poems at the scene of two of his crimes. He held up Wells Fargo

Wells, Fargo & Company's express office, C Street, Virginia City. Albumen stereograph by Lawrence & Houseworth (1866). *Courtesy Library of Congress.*

stagecoaches twenty-eight times. The fourteenth of these holdups was in Jackson County, Oregon, three miles from the California border. In 1877, at his fourth holdup, he left the following verse:

> *I've labored long and hard for bread,*
> *For honor, and for riches,*
> *But on my corns too long you've tread,*
> *You fine-haired sons of bitches.*

SEPTEMBER 23, 1962: "JANE! STOP THIS CRAZY THING!"

So said George Jetson of *The Jetsons*, an animated Hanna-Barbera series about a space age family and a counterpart to *The Flintstones*. The show was

ABC-TV's first color program. It ran from September 23, 1962, to March 17, 1963, and has been broadcast in reruns ever since. The show imagined various futuristic devices that had not yet been invented, including flatscreen 3-D televisions, newspapers read on a digital tablet, a computer virus, video chat, tanning beds and home treadmills.

SEPTEMBER 24, 1855: A GRUESOME SALE

Joaquin Murieta's preserved head and Three-Fingered Jack's hand were sold at auction for thirty-six dollars. The men were considered Mexican outlaws, or Robin Hoods, depending on one's opinion of their retaliatory attacks against racist gold-miner culture. Murieta's head and Three-Fingered Jack's hand were displayed around the state and then were said to have disappeared in San Francisco during the 1906 earthquake. The gruesome items were also said to be cursed. Two owners (other than Murieta and Jack) of the body parts died mysteriously.

SEPTEMBER 25, 1890: TRAIL OF 100 GIANTS

Sequoia National Park, famous for its enormous trees, opened. The southern Sierra Nevada park east of Visalia covers 404,063 acres. It includes Mount Whitney, which is the highest point in the lower forty-eight states. The park borders Kings Canyon National Park; together, they're known as the Sequoia and Kings Canyon National Parks. One of the most popular attractions is the Trail of 100 Giants.

SEPTEMBER 26, 1846: AT RANCHO CHINO

After Los Angeles surrendered to U.S. forces, Californios forced the invading military out in the rebellious Siege of Los Angeles in August. Then, two dozen armed Americans who had become Mexican citizens but were still loyal to the United States gathered at Rancho Chino to plan their next step. But before they could act, Californios surrounded the

Sequoia National Park village with Sentinel Tree (Giant Forest Village). Photograph by Matson Photo Service (September 1957). *Courtesy Library of Congress.*

house, began shooting and threatened to burn the house down before the American sympathizers surrendered and were marched away to Paredon Blanco, now Boyle Heights.

SEPTEMBER 27, 1998: HAPPY BIRTHDAY, GOOGLE

Google, based in Mountain View, claims this date as its birthday. The website Google.com was registered on September 15, 1997, but in 2005, the firm chose September 27 as its birthday, because on this date it first processed a record-breaking number of pages.

SEPTEMBER 28, 1963: SURF'S UP

"Little Deuce Coupe" by the Beach Boys, from Hawthorne, crested on the Billboard chart at no. 15 after starting as the B side to "Surfer Girl." "Little Deuce Coupe" later became the title song for their fourth album. On the very same day, "Surfer Joe" by the Surfaris, from neighboring Glendora, peaked at no. 62 on the Billboard chart after starting as the A side to "Wipe Out." On the same day in 1964, the Beach Boys released "Surfin' USA" as a 45rpm single and on an album. It had originally hit no. 2 on the Billboard charts in 1963.

SEPTEMBER 29, 1946: RAMS

The Los Angeles Rams, having recently moved from Cleveland, played their first NFL game in LA. They were the first team to racially integrate. When halfback Fred Gehrke painted horns on their helmets in 1948, they became the first pro football team with a modern helmet emblem. The Rams left LA for St. Louis in 1994. In 2016, the team returned to Los Angeles.

SEPTEMBER 30, 1962: AGENT OF CHANGE

Cesar Chavez, Mexican American labor leader and central figure in civil rights in California, founded the National Farm Workers Association, which later became the United Farm Workers. Today, that union is a powerful political force.

Sculpture in Cesar Chavez Plaza, downtown Sacramento, California. Photograph by Carol M. Highsmith (2012). *Courtesy Library of Congress.*

October

OCTOBER 1, 1964: FREE SPEECH

The free speech movement began at UC Berkeley. Mario Savio led the protest to guarantee students' freedom to distribute political brochures on campus. The administration cracked down on political activities like those associated with the civil rights movement, sparking a reaction that ignited the protest. Similar struggles spread to campuses nationwide. Conflicts between students and the UC Berkeley administration continued for years. Today, the free speech movement is commemorated at the "Mario Savio Steps," where the protests took place, and at the Mario Savio Free Speech Movement Café in the undergraduate library.

OCTOBER 2, 1950: MEET PEANUTS

Peanuts, the comic strip written and drawn by Charles Schulz of Santa Rosa, debuted in nine newspapers. It grew into the most popular and influential strip in history. Schulz eventually created 17,897 strips, an epic narrative that's been called "arguably the longest story ever told by one human being." Peanuts was ultimately published in twenty-six hundred newspapers and read by some 355 million people in twenty-one languages and in seventy-

Charles Schulz with drawing of Charlie Brown. *World Telegram & Sun* photo by Roger Higgins (1956). *Courtesy Library of Congress.*

five countries. It has spun off merchandise, productions in theaters and on ice, classic TV specials and movies.

OCTOBER 3, 2004: THE SHOWER SCENE

Jeanette Morrison, the actress known as Janet Leigh, famous for her role in Alfred Hitchcock's *Psycho*, died in Beverly Hills at age sixty-seven. Born in Merced, she was "discovered" on a ski slope, brought to Hollywood, began her career on radio and performed in a wide variety of roles before Hitchcock cast her in *Psycho*. The scene in the film in which she is slashed to death in the shower so rattled Leigh that she avoided taking showers for the rest of her life.

OCTOBER 4, 1880: USC BIRTHDAY

The University of California, now known as the University of Southern California, was founded in Los Angeles. Along with a college of liberal arts, the university established a band and a debate team. The fifty-three students paid a tuition of $15. The 1884 graduating class, USC's first, matriculated two males and a female valedictorian named Minnie Miltimore. Today, California's oldest private research university contributes approximately $5 billion annually to the economy of the Los Angeles county area.

OCTOBER 5, 1945: BLACK FRIDAY

A six-month strike by Hollywood set decorators turned into a bloody brawl between strikers and strikebreakers at the main gate to the Warner Bros. studios, an event known as "Hollywood Black Friday." The situation turned violent when strikers overturned the cars of replacement workers driving through picket lines. Reinforcements on both sides fought until some three hundred police, deputies and studio security workers quelled the confrontation. A return to the bargaining table settled the strike a month later and inadvertently spurred passage of the Taft-Hartley Act, which limited the power of labor unions. Some of these events are depicted in Thomas Pynchon's novel *Vineland* (1990).

OCTOBER 6, 1963: DODGERS SWEEP

The Los Angeles Dodgers swept the two-time defending champion New York Yankees to claim their second World Series victory. The Yankees seemed the dominant team after a 104-57 season, claiming a fourth straight American League pennant with a roster featuring Mickey Mantle, Roger Maris, Elston Howard, Joe Pepitone and Whitey Ford on the mound. But Dodgers pitchers Sandy Koufax, Don Drysdale, Johnny Podres and ace reliever Ron Perranoski allowed New York only four runs in four games. During the MVP ceremony in New York City, as Koufax was awarded a new car, a NYPD officer placed a parking ticket on its windshield.

OCTOBER 7, 1846: DONNER PARTY CRUELTY

While ascending the eastern slope of the Sierra Nevada, after months of exhausting trekking, Louis Keseberg lightened his load by putting elderly Mr. Hardkoop, a Belgian traveling west, out of his wagon. Hardkoop was last seen sitting by the side of the road. Keseberg survived starvation at Donner Lake by resorting to cannibalism, reportedly devouring Mrs. Tamsen Donner. After his rescue, remarkably, he tried his hand at running a boardinghouse in Sacramento.

OCTOBER 8, 1846: OLD WOMAN'S GUN

The Battle of the Old Woman's Gun is named after a brass cannon that was buried in Inocencia Reyes's garden and dug up and fired against U.S. forces in a battle of the Mexican-American War fought at Dominguez Rancho near Los Angeles. LA had surrendered, but the Californios revolted and retook their town in what was called the "Siege of Los Angeles." U.S. forces attempted to recapture LA but were turned back to their ships after an hour-long engagement. Their four fatalities were buried on what became known as the Island of the Dead in San Pedro Bay.

OCTOBER 9, 1542: EL CONQUISTADOR

Juan Rodríguez Cabrillo, the first European to navigate and chart the California coast, anchored in Santa Monica Bay, which he named "Bahia de los Piños." He had fought with Cortés in Mexico and made a fortune in the slave trade and gold mining before sailing under the Spanish flag in

Santa Monica Bay. Photograph copyright W.D. Lambert (circa 1908). *Courtesy Library of Congress.*

search of trade opportunities or the fabled Strait of Anián that connected the Pacific and Atlantic Oceans. Cabrillo sailed as far north as the Russian River before returning south without achieving his objectives, although he established Spain's territorial claim to new lands.

OCTOBER 10, 1911: A NARROW VICTORY

Women's suffrage, the right to vote, barely passed in California. Los Angeles voters supported it, while voters in San Francisco did not, resulting in a victorious margin of 3,587 votes. California was the sixth state to recognize women's suffrage, following Wyoming, Colorado, Utah, Idaho and Washington. An attempt to enfranchise California women in 1896 was denied by Bay Area voters. The Liquor Dealers League, a collection of liquor producers, bar owners and their customers, is credited with leading the defeat.

Woman Suffrage Picketing at Senate Office Building: Mildred Gilbert of California; Pauline Floyd of [Washington] *D.C.; Vivian Pierce, California.* Photograph by Harris & Ewing (1918). *Courtesy Library of Congress.*

OCTOBER 11, 1906: SCHOOL SEGREGATION

Growing anti-Japanese attitudes in California prompted the San Francisco School Board to order that Japanese students attend segregated schools. California was experiencing increased immigration after the Russo-Japanese War, worsening racial tensions after the 1906 earthquake and widespread anti-Asian attitudes inflamed by newspaper publisher William Randolph Hearst. Japan responded with outrage. President Theodore Roosevelt requested the order be rescinded, promising to reduce Japanese immigration in exchange. International trade and diplomatic relations were strained. But racist attitudes persisted, and anti-Japanese rioting broke out in San Francisco in May 1907.

OCTOBER 12, 1933: FEDERAL PEN

Cell Block A, Alcatraz Federal Penitentiary, Alcatraz Island, San Francisco Bay, California. (no date). *Courtesy Library of Congress.*

The U.S. Department of Justice transferred Alcatraz to the Federal Bureau of Prisons to hold dangerous prisoners transferred from other federal prisons, including Al Capone, Robert Franklin Stroud (the "Birdman of Alcatraz" who spent forty-two years in solitary confinement) and James "Whitey" Bulger. Life was harsh. There were fourteen escape attempts, none known to have succeeded. The prison eventually closed and the island abandoned until it was occupied from 1969 to 1971 by American Indians claiming indigenous rights to the land. Alcatraz is said to be one of the most haunted places in the United States. Today, the island prison is one of the most popular tourist attractions in the San Francisco area.

OCTOBER 13, 1843: RARE RANCHO

Rancho Olompali, an 8,877-acre Mexican land grant named for a neighboring Coast Miwok village, was deeded to Camilo Ynitia, the last traditional leader of the local Miwok village. He had won favor by signing a treaty between the Olompali people and the Mexican government. In 1846, during the Bear Flag Revolt, Olompali became the site of a battle between Yankees liberating California from

Mary Burdell Garden, Olompali State Historic Park, Novato, California. Photograph by Brian Grogan (2007). *Courtesy Library of Congress.*

Mexico and Mexican forces sent to defeat them. In the 1960s, the Grateful Dead lived in an art deco mansion on the property. Today, Olompali is a California State Historic Park in Marin County.

OCTOBER 14, 1864: BAD DAY FOR MODOCS

Klamaths, Modocs and the Yahooskin band of Snake Indians signed away some twenty million acres of their traditional homeland along the California-Oregon border to live peacefully with government provisions on a small reservation. Provisions were delayed for years and never fairly distributed. Intertribal tension, hunger and homesickness eventually spurred a band of Modocs to return home, precipitating the disastrous Modoc War of 1872–73. Meanwhile, their tribal struggles for land rights continues, as reflected in their Facebook group "Honor the Treaty of 1864."

OCTOBER 15, 1966: BEFORE BLACK LIVES MATTER

Huey Newton and Bobby Seale established the Black Panther Party for Self-Defense in Oakland. Formed partly in response to Bay Area police killing unarmed black men, armed Black Panthers patrolled and monitored

police officers to curb unchecked brutality. The organization issued a ten-point program demanding adequate housing, jobs, education, an end to police brutality, exemption from military service, the freeing of black men from prisons and more. J. Edgar Hoover, the FBI director, considered them "the greatest threat to the internal security of the country." Although membership peaked in 1970 with offices in sixty-eight cities, government infiltration, internal dissent and police raids began to tear apart the organization.

Black Panther Convention, Lincoln Memorial. Photograph by Thomas J. O'Halloran and Warren Leffler (June 19, 1970). *Courtesy Library of Congress.*

OCTOBER 16, 1923: DISNEY BUSINESS

Walt and Roy Disney launched the Disney Brothers Cartoon Studio in Los Angeles with a contract to produce "Alice Comedies," cartoons about a girl living in a cartoon world. Their next series featured Oswald the Lucky Rabbit. Unluckily for the brothers, they overlooked copyrighting their material and had its ownership taken away. They did not repeat that mistake with their next character, Mickey Mouse, who did not speak until his third cartoon, *Steamboat Willie*, which premiered on November 18, 1928. The rest is history.

OCTOBER 17, 1989: WORLD SERIES EARTHQUAKE

The Loma Prieta Earthquake ruptured the San Francisco area at the start to the third game of the World Series pitting the Oakland Athletics against the San Francisco Giants. As such, the earthquake became the first major U.S. quake broadcast live on national television. It centered in the Santa Cruz Mountains, where shaking lasted some fifteen seconds, but the effects were felt miles away in the San Francisco Marina District and on the Oakland-Bay Bridge, where a fifty-foot section collapsed. In Santa Cruz, 40 buildings fell. The quake resulted in 63 deaths and 3,757 injuries. Damage was estimated at $7 billion to some 28,000 structures and several freeways in one of the most expensive natural disasters in U.S. history at the time.

OCTOBER 18, 1967: DISNEY DOES KIPLING

Walt Disney Productions, headquartered in Burbank, released *The Jungle Book*, inspired by Rudyard Kipling's 1894 novel. Disney's nineteenth animated classic was a critical and box office success. But there were numerous struggles behind the scenes. Bill Peet, a children's book author and illustrator and Disney talent, bolted from the studio over artistic disagreements. Disney had his own vision of the film, telling his writer, "The first thing I want you to do is not to read it." He meant Kipling's book.

OCTOBER 19, 1842: EXCUSE ME!

Acting on rumors of war, U.S. naval commodore Thomas ap Catesby Jones captured Monterey, the capital of Alta California, which surrendered without a fight. A battalion of marines marched ashore and raised the flag as a naval band played patriotic tunes. Unfortunately for Jones, there was no war (yet), so he extended his best diplomatic apologies, departed and was relieved of his duty soon afterward. He served with distinction in the Mexican War four years later.

OCTOBER 20, 1991: OAKLAND FIRESTORM

A firestorm devastated the Oakland and Berkeley hills, burning 1,520 acres, killing 25 people and injuring 150 others. It destroyed 2,843 single-family homes plus 437 apartments and condos. The loss has been estimated at $1.5 billion. At it most intense, a house burned every eleven seconds. Will Wright, who lost his home, drew inspiration from the rebuilding process to create the computer game *The Sims*.

OCTOBER 21, 1868: HAYWARD EARTHQUAKE

The most devastating earthquake in the San Francisco Bay Area before 1906 stuck the Hayward Fault with an estimated magnitude of 7 on the

Richter scale. It essentially flattened the town of Hayward, across the bay from San Francisco. An area in San Francisco sank, creating what became known as Pioche's Lake, which was filled. Rooming houses were then built there. They all fell in the 1906 earthquake, killing some five hundred people. The average interval between each of the past five large earthquakes on the Hayward Fault is 140 years—another is due at any time.

OCTOBER 22, 1972: DROUGHT BREAKER

The Oakland Athletics won the World Series championship by beating the Cincinnati Reds, four games to three. The A's and Reds were dominant teams in the 1970s, winning five titles rings between them that decade. This victory was especially sweet, as it was Oakland's first World Series trip and the team's first title since 1931, when it called Philadelphia home.

OCTOBER 23, 1941: FLY BY THE EARS

Dumbo, the fourth Walt Disney animated classic, was released. Disney intended for the film to recoup financial losses from the experimentally elaborate *Fantasia* and return to simple, economic moviemaking. It worked. Since its release, Disney has celebrated *Dumbo* in a TV series, books, theme parks, video games and live performances.

OCTOBER 24, 1963: RARE TALENT

Sandy Koufax of the Los Angeles Dodgers won the Cy Young Award by an unanimous vote. He also won unanimously in 1965 and 1966. His short-lived career, ended by arthritis in his pitching elbow, was one of the most phenomenal is baseball history. Koufax is also remembered for refusing to pitch in Game 1 of the 1965 World Series because of his observance of a Jewish holiday.

OCTOBER 25, 1879: BANDIT POET STRIKES AGAIN AND AGAIN

Charles Earl Boles, the English-born poet bandit known as Black Bart, held up Wells Fargo stagecoaches twenty-eight times. The tenth robbery was in Shasta County, along the road to Buckeye. Known for doggerel poems he left at the scene of a couple of his robberies, Boles was ultimately identified by a handkerchief he inadvertently left behind.

OCTOBER 26, 1861: DISRUPTIVE TECHNOLOGY

The Pony Express announced its closure two days after the transcontinental telegraph connected Omaha, Nebraska, with Sacramento. The telegraph line was built in just 112 days. Western Union installed ten to twelve miles of cable daily, rendering the eighteen-month-old Pony Express immediately obsolete. It had taken ten days to deliver a message from St. Joseph to Sacramento by horse; now, it was done almost instantly.

Strongbox and cradle at the Pony Express Courier Building, Placerville, California (no date). *Courtesy Library of Congress.*

OCTOBER 27, 1954: DISNEY ON THE AIR

Walt Disney's first television program, *Disneyland*, premiered on ABC, featuring Davy Crockett, Indian Fighter in five hour-long episodes, which some contend was the first miniseries. Its popularity gave Disney the idea to capitalize on its success by merchandizing Davy Crockett paraphernalia, like coonskin caps and bubblegum cards.

OCTOBER 28, 1929: IN-FLIGHT ENTERTAINMENT

Universal Pictures, headquartered in Los Angeles, joined with Transcontinental Air Transport to offer in-flight movies for air passengers bound for California. The first in-flight movie, however, *Howdy Chicago*, was shown on Aeromarine Airways in 1921 as the amphibious plane flew around Chicago. Later in-flight entertainment included live performances.

OCTOBER 29, 2012: GROWING A KINGDOM

The Walt Disney Company, in Burbank, purchased Lucasfilm, Ltd., of San Francisco, and the rights to the Star Wars and Indiana Jones franchises for $4.05 billion. Some imagine that Disney will feature the series' heroes not just in new films but also at theme parks, in books and in video games.

OCTOBER 30, 1974: SIT DOWN!

Nolan Ryan of the California Angels threw the fastest recorded pitch in Major League Baseball history, clocked at 100.9 miles per hour. He later topped that speed at 108.1 miles per hour. The man nicknamed the "Ryan Express" also holds records for pitching seven no-hitters and 5,714 career strikeouts, including striking out 383 batters in a single season.

OCTOBER 31, 1913: COAST TO COAST

The Lincoln Highway, the first U.S. transcontinental highway, was dedicated. It ran from Times Square in New York City to Lincoln Park in San Francisco. Unlike the interstate highways of today, it was a patchwork of roads running through some seven hundred cities, towns and villages—it was called the "Main Street Across America." Cities and towns along the route celebrated its opening with torchlit parades, bonfires, dances and cannon fire. The Union Pacific Railroad donated three carloads of railroad ties for the bonfire in Omaha, Nebraska.

November

NOVEMBER 1, 1876: GLASS CEILING SHATTERS

Lucy Field Wanzer became the first female medical school graduate west of the Rocky Mountains when she graduated from UC Medical School. Her application was initially rejected. She appealed and, after a four-month process, was admitted. Hazing followed. A professor told her that women who want to study medicine should have their ovaries removed. Wanzer replied that male medical students should have their testicles removed. After graduation, she and a group of other women established Children's Hospital in San Francisco.

NOVEMBER 2, 1895: SHOOT-THE-CHUTE

The Chutes amusement park, which claimed to be "the largest pleasure resort in America," opened on Haight Street in San Francisco. It featured a waterslide that let thirty people at a time ride a speeding toboggan down a 350-foot-high water chute into a huge pool. Such slides were all the rage at the time. There was one on Coney Island in New York. The San Francisco Chutes was the only amusement park in the city that survived the 1906 earthquake.

NOVEMBER 3, 1883: BANDIT POET'S DEMISE

Charles Earl Boles, the English gentleman bandit known as "Black Bart" who held up Wells Fargo stagecoaches twenty-eight times and left poems at the scenes of two of his crimes, was wounded at Funk Hill in Calaveras County during this final attempt. While making a quick escape, he dropped a handkerchief that was used to identify him. He was later arrested.

NOVEMBER 4, 1775: INDIANS REVOLT

Kumeyaay warriors surrounded Mission San Diego, set fire to the wooden structures, attacked the soldiers and killed Father Luís Jayme in what was the first of a dozen revolts against Spanish conquest during the mission era.

Mission San Diego de Alcala, San Diego, California. Photograph by Henry F. Withey (December 1936). *Courtesy Library of Congress.*

NOVEMBER 5, 1911: CROSS-COUNTRY FLIER

Calbraith Perry Rodgers became the first aviator to complete a transcontinental flight. He was competing for William Randolph Hearst's $50,000 prize to the first aviator to complete a cross-country flight in less

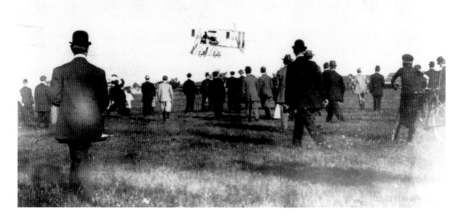

Calbraith Perry Rodgers aloft in a plane (1911). Courtesy Library of Congress.

than thirty days. Rodgers didn't win it, having taken off from New York on September 17 and landing in Pasadena fifty-two days later after numerous scheduled and accidental stops.

NOVEMBER 6, 1990: FIRE ON THE SET

Arson by a security guard with a cigarette lighter in a Brownstone Street alley destroyed 20 percent of the standing sets at Universal Studios. Courthouse Square for *Back to the Future* went up in flames, along with sets from *Ben Hur* and a New York street scene. Some four hundred firefighters from eighty-six companies responded. Losses were estimated at around $50 million.

NOVEMBER 7, 1989: NIGHT STALKER

Richard Ramirez, convicted of thirteen "Night Stalker" murders, was sentenced to death in Los Angeles on each charge. His murderous home-invasion spree terrorized people in the Los Angeles and San Francisco areas from June 1984 until August 1985. He was spotted by a group of elderly Mexican women in LA, then pursued and subdued by a band of citizens.

NOVEMBER 8, 1957: ROMANCE OF THE SKIES TRAGEDY

Romance of the Skies, a Pan American World Airways airplane on a flight around the world, crashed in the Pacific Ocean on its way from San Francisco to Hawaii, killing a crew of eight and thirty-eight passengers. The luxury plane provided seven-course dinners from Maxim's of Paris, a lounge at the bottom of a spiral staircase and private sleeping compartments for its wealthy travelers. The cause of the crash remains a mystery.

NOVEMBER 9, 1848: GOLD RUSH P.O.

The first U.S. post office in California opened in San Francisco. When more than 45,000 undeliverable letters piled up, the overwhelmed and panicked clerks barricaded themselves inside for protection from the crowd.

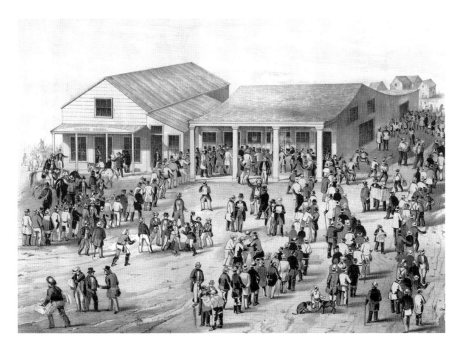

Post office, San Francisco, California. Lithograph by William Endicott & Company after H.F. Cox. Wm. Endicott & Company, New York (circa 1850). *Courtesy Library of Congress.*

NOVEMBER 10, 1849: GLOBAL GOLD RUSH

Abandoned ships in Yerba Buena Cove, San Francisco, California (1849–50). *Courtesy Library of Congress.*

James Collier, the collector of the port in San Francisco, reported that 697 ships had arrived in the bay since April 1, 1849; 401 of them flew the American flag and 296 were from other nations. Today, the port is a hub of international tourism and shipping.

NOVEMBER 11, 1981: FERNANDOMANIA

Fernando Valenzuela, a Los Angeles Dodgers pitching phenomenon, became the first and only baseball player to win the Rookie of the Year and the Cy Young Awards. The crazy enthusiasm for him, known as Fernandomania, is understandable, since he won his first eight starts, five as shutouts. Shoulder problems eventually ended his career on the field. Today, Valenzuela broadcasts for his old team.

NOVEMBER 12, 1981: BALLOON FIRST

The Double Eagle V, the first balloon to cross the Pacific Ocean, landed in the Mendocino National Forest after traveling 5,768 miles from Japan in eighty-four hours and thirty-one minutes. Rocky Aoki, a retired wrestler, competitive thrill-seeker and founder of Benihana steakhouse, was part of the crew. Two of the others had flown balloons across the Atlantic Ocean.

NOVEMBER 13, 1940: DISNEY DOES STEREO

Walt Disney released *Fantasia*, an experimental animated musical and the first commercial film employing stereo sound. Due to cost overruns and World War II, it lost money initially but today ranks among the highest-grossing films in history. The film, originally designed to revive Mickey

Mouse's slacking popularity, evolved into a unique, artistically ambitious project involving more than one thousand artists and technicians.

Corridor and laser lab, first floor, Hughes Aircraft Company, Processing & Electronics Building, Los Angeles, California. Photograph by David De Vries (1995). *Courtesy Library of Congress.*

NOVEMBER 14, 1967: MEET THE LASER

Theodore Maiman of the Atomic Physics Department at Hughes Aircraft Company, headquartered in Glendale, patented the world's first laser, a word that is an acronym for "light amplification by stimulated emission of radiation." The use of lasers today is ubiquitous to modern life, found in barcode readers, laser printers, public light shows and precision guided military missiles.

NOVEMBER 15, 1929: MICKEY PLAYS JUNGLE ANIMALS

Walt Disney released *Jungle Rhythm*, a short film featuring Mickey Mouse using jungle animals as musical instruments. The film is short on storytelling but long on silliness. Wandering into a jungle, Mickey encounters elephants, monkeys and lions, all of which he turns into instruments as the jungle dances. Critics point out that, along with there being no plot, there is no dialogue and no singing. Exactly three years later, on November 15, 1932, Walt Disney opened an art school for his animators.

NOVEMBER 16, 2012: CALL OF DUTY

In just twenty-four hours, Activision, located in Santa Monica, grossed $500 million from Call of Duty: Black Ops 2. It was the biggest entertainment launch in history. The entire Call of Duty multi-titled series has sold more

than 175 million units, with U.S. sales topping $15 billion as of April 2015. Its success is such that Call of Duty Endowment (CODE) has spun off a nonprofit foundation created by Activision Blizzard to help find employment for U.S. military veterans.

NOVEMBER 17, 2010: STUDENTS PROTEST

Some three hundred students and employees at UC San Francisco's Mission Bay campus protested a sixth tuition increase in four years. Protesters were pepper-sprayed, thirteen were arrested and three police officers were injured. The UC Board of Regents increased tuition fees by 8 percent the next day. It had increased tuition by 32 percent the previous year.

NOVEMBER 18, 1978: JONESTOWN MASSACRE

California congressman Leo Ryan and members of a delegation were murdered on an airport tarmac when they flew to Guyana to investigate Jim Jones's Peoples Temple. That attack led to the murder and suicide of some 900 people at the temple compound, including 260 children. Jones, the charismatic cult leader, at one time headed a congregation of 20,000 from his church headquartered in San Francisco.

NOVEMBER 19, 2010: SMALL BUT MIGHTY

The Los Angeles Auto Show opened, showcasing the iconic Fiat 500, built in the United States. The Italian "people's car," introduced more than fifty years earlier, was considered one of the first city cars. While European loyalists point to the car's durability and economy, U.S. sales peaked in 2012, then suffered setbacks from competition by an array of nearly identical domestic and international brands.

NOVEMBER 20, 1969: TRIBES FREE THE ROCK

Eighty-nine American Indians and their supporters occupied Alcatraz Island in the name of "Indians of All Tribes." Their claim to rights to the land referenced the Treaty of Fort Laramie (1868), signed by the United States and the Lakota tribe. The agreement stipulated that retired, abandoned or out-of-use federal land be returned to the native people from whom it was taken. Alcatraz Federal Penitentiary had been closed for more than six years, and the island had been declared surplus federal property. The Indians offered to buy it for twenty-four dollars in beads and cloth (the price supposedly paid to Indians for Manhattan in 1626) and demanded an American Indian University, museum and cultural center. Federal forces forcibly ended the occupation after nineteen months. The occupation was a defining event in Indian activism at the time.

NOVEMBER 21, 1969: WWW BEGINS

The first permanent ARPANET (Advanced Research Projects Agency Network) link was made between UCLA and Stanford Research Institute. This was the genesis of the Internet. The first successful message had been sent by UCLA student programmer Charley Kline on October 29, 1969. It read, "login." In a previous attempt, the letters "l" and "o" transmitted, then the system crashed. So, the first actual message over the ARPANET read "lo."

NOVEMBER 22, 1995: TOY STORY PREMIERS

Pixar, then headquartered in Point Richmond, released *Toy Story*, the first feature-length film completely created with computer-generated imagery. The film found a sweet spot with children and adults, making it the highest-selling film for three weeks in a row. The initial goal was earnings of $75 million, but the movie made over $361 million worldwide in its run. It was a technical milestone in moviemaking, the biggest game-changer after the introduction of color. Since the release of *Toy Story*, there have been 250 computer-animated films.

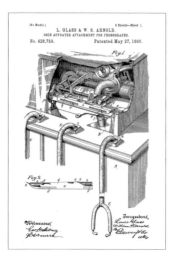

L. Glass and W.S. Arnold of San Francisco. *Coin Actuated Attachment for Phonograph.* U.S. patent number 428,750. *Courtesy U.S. Patent and Trademark Office.*

NOVEMBER 23, 1889: MEET THE JUKEBOX

The first jukebox began playing at the Palais Royale Saloon in San Francisco. Built by the Pacific Phonograph Company, it had tubes attached to an Edison phonograph inside an oak cabinet. Four coin-activated tubes operated individually, allowing four people to listen to the same song at the same time.

NOVEMBER 24, 1930: WOMEN'S SPEED RECORD

Ruth Rowland Nichols set a women's transcontinental speed record, flying from New York to California in a Lockheed-Vega. She beat Charles Lindbergh's time. Nichols, a friend of Amelia Earhart, was the only woman to hold simultaneous world records for speed, altitude and distance; the first woman with a hydroplane license; and first female pilot of a commercial passenger airline.

NOVEMBER 25, 1947: McCARTHYISM IN HOLLYWOOD

Movie studio executives identified the "Hollywood Ten," actors and directors whom they would not hire after they were jailed for refusing to cooperate with the House Un-American Activities Committee. The men accused of being members of the Communist Party were targets of Cold War hysteria and Senator Joe McCarthy. Soon, some 150 more individuals were tarred and blacklisted, ruining many careers.

NOVEMBER 26, 1913: NO WOMEN ALLOWED

The San Francisco chief of police issued an order stopping women from visiting local pavilions during prizefights. Even after passage of the Nineteenth Amendment, women were still as scarce as hen's teeth at prizefights. A newspaper report on the Jack Dempsey–Jess Willard fight in Toledo, Ohio, on July 4, 1919, remarked: "For the first time in boxing history women had been encouraged to attend, and a special canvas-covered pavilion was provided near the outer reaches of the arena. An estimated five hundred women filled this section, and although here and there throughout the big arena there were other women, the majority were relegated to their own special section."

NOVEMBER 27, 1941: ANOTHER BREAKAWAY TERRITORY

Jefferson declared itself an independent state in "patriotic rebellion against the States of California and Oregon" and planned to "secede every Thursday until further notice." However, local support for this short-lived but long-remembered rebellion in the separatist tradition of the remote region, arguably akin to the breakaway Nataqua Territory (1859), faded in the patriotic fervor following Japan's bombing of Pearl Harbor on December 7, 1941.

NOVEMBER 28, 1866: "BIDDY" GETS STARTED

Margaret "Biddy" Mason bought her first piece of Los Angeles real estate. Born into slavery in Georgia, Mason was brought to California in bondage, won her freedom in court, became a midwife, invested in real estate, founded a church, established an elementary school for black children, took in the poor and became a philanthropist. She was lovingly called "Mother" Mason. Sheila Levrant de Bretteville's eighty-two-foot-long concrete art wall in downtown Los Angeles depicts Mason's life story.

NOVEMBER 29, 1972: PONG

Atari's Pong, the first commercially successful video arcade game, was first played at Andy Capp's Tavern in Sunnyvale. It is essentially a two-dimensional graphical iteration of ping-pong. Mesmerizingly simplistic as it seems in retrospect, Pong launched an industry that generated some $93 billion in 2013.

NOVEMBER 30, 1991: LOST IN THE DUST

On this date, 17 people died and 150 were injured when some one hundred cars and trucks crashed during a blinding dust storm on Interstate 5 near Fresno. The mile-long column of wrecked and smoldering vehicles reminded some of a scene from a war zone. Crews clearing the road were alarmed to find industrial-sized, potentially explosive oxygen tanks among baby-food jars in a burned tractor trailer. The crash was the deadliest highway pileup in California history.

December

DECEMBER 1, 2006: TREE-SITTERS ASCEND

Protesters in Berkeley began sitting in trees that UC Berkeley planned to cut down near Memorial Stadium to build an athletic training center. The last four protesters came down on December 9, 2008. Tree-sitting as a form of social protest achieved fame when Julia "Butterfly" Hill protested logging by camping in a 180-foot-tall California redwood tree from December 1997 to December 1999.

DECEMBER 2, 1818: PIRATES ATTACK

After burning Monterey, Spain's colonial capital of Alta California, Hippolyte Bouchard and his four hundred pirates sailed south to plunder the Nuestra Señora del Refugio rancho. He lost three men there but got them back by threatening to pillage Santa Barbara if his men were not returned. Bouchard considered himself a privateer serving Argentina's revolt from Spanish domination by attacking its Pacific colonies.

DECEMBER 3, 1786: WEDDING BELLS

The first marriage was performed at the Santa Barbara Presidio. Joseph Calisto, a twenty-three-year-old Spanish soldier, wed Juana Vitala Feliz, who was about thirteen years old. They eventually had thirteen children.

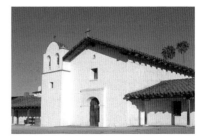

El Presidio Real de Santa Bárbara in Santa Barbara, California. Photograph by Carol M. Highsmith (2012). *Courtesy Library of Congress.*

DECEMBER 4, 1965: "MASHI"

Masanori "Mashi" Murakami, who pitched for one season with the San Francisco Giants, returned to Japan to play for the Nankai Hawks of Osaka. As a pitcher for the Giants, he averaged more than one strikeout per inning, posted an ERA under four and earned eight saves. Murakami was the first Japanese player on a Major League Baseball team. Back in Japan, he played another seventeen seasons before returning to the Giants as a batting-practice pitcher and scout.

DECEMBER 5, 2011: BLACK HOLES

UC Berkeley astronomers reported locating two extraordinarily large black holes, each ten billion times the mass of our sun, in galaxies more than three hundred million light-years away. Their mass and power is difficult to imagine. Each black hole has a gravitational force that spans four thousand light-years. Black holes largely remain scientifically awesome mysteries.

DECEMBER 6, 1969: AN ERA ENDS

The Rolling Stones performed at Altamont Speedway in Livermore in what was expected to be an event similar to the Woodstock festival in New York. But it turned hellish. Some three hundred thousand people were drawn to the free concert on the eastern edge of the San Francisco Bay Area,

overwhelming the facility. Hells Angels members were hired for security but became violently out of control themselves, as were many concertgoers. Angels beat to death Meredith Hunter during the show. Three other people died in unrelated events, one by drowning in a nearby canal and two killed by a runaway car.

DECEMBER 7, 2009: SPACE TRAVEL

Virgin Galactic unveiled its first commercial spaceship at the Mohave Air and Space Port. Trips aboard the VSS *Enterprise* to the edge of space were expected to cost $200,000 per person. After years of testing, however, the spaceship was tragically destroyed during a test flight in 2014. Testing a new vehicle for space flight continues.

DECEMBER 8, 1969: BLACK LIVES MATTER HISTORY

Hundreds of Los Angeles police officers raided the Black Panthers headquarters, arresting adults and children. During a shootout, Roland Freeman, founding member of the Southern California chapter of the Black Panther Party for Self-Defense, was shot but survived. The battle followed a similar armed raid days earlier against Black Panthers in Chicago. Coming days after the violence at Altamont, the four-hour shoot-out in Los Angeles closed the book on an era that began with 1967's Summer of Love.

DECEMBER 9, 1968: MOTHER OF ALL DEMOS

Douglas Engelbart, electrical engineer and Internet visionary at Stanford Research Institute, demonstrated the computer mouse, hypertext and the bit-mapped graphical user interface using the oN-Line System (NLS). All of these features have become integral to how the Internet works and the ways we interact with it. His demonstration is known as "The Mother of All Demos."

DECEMBER 10, 1930: SHE DID IT AGAIN

Ruth Rowland Nichols, aerial speed demon, set a women's record for coast-to-coast flight, winging from Los Angeles to New York in thirteen hours, twenty-two minutes. She broke her own record of sixteen hours, fifty-nine minutes and thirty seconds, set on November 24, 1930 flying east to west.

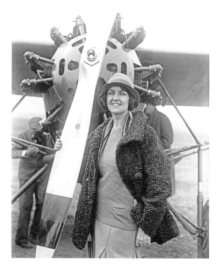

Ruth Nichols (March 19, 1929). Courtesy Library of Congress.

DECEMBER 11, 1932: RECORD COLD

San Francisco recorded a temperature of 27 degrees Fahrenheit, its coldest day ever—and it snowed. It rarely snows in San Francisco. The snowiest decade was the 1880s, when snow fell in 1882, 1884, 1887 and 1888.

DECEMBER 12, 1925: MOTOR HOTELS

Arthur Heineman coined the term motel—a motor hotel—when he opened the Motel Inn in San Luis Obispo. He planned a chain of eighteen motor lodges situated along the Pacific coast, spaced one day's drive apart. (This resembled the mission system, in which missions were spaced one day's horseback ride apart.) It was a great idea, perfectly timed for the burgeoning car culture. Unfortunately, Heineman failed to trademark the name, which became generic, and competitors ran him out of the motel business.

Palomino Motel sign in Sweetwater, Texas. Photograph by Carol M. Highsmith (March 8, 2014). *Courtesy Library of Congress.*

DECEMBER 13, 1944: RECORD READINGS

Los Angeles recorded a record low temperature, 28 degrees Fahrenheit. Eight years later, in 1952, the record high was 83 degrees. Twenty-three years later, on December 13, 1967, snow fell in San Diego after temperatures plunged 19 degrees in eight hours.

DECEMBER 14, 1963: DEVASTATING FLOOD

The Baldwin Hills Reservoir in Los Angeles broke open, releasing 250 million gallons of water into the surrounding neighborhood in three hours, destroying 277 homes and killing five people. It was reminiscent of the St. Francis Dam collapse in 1928 that killed some four hundred people. While the cause of the failure has never been absolutely identified, building the facility over an earthquake fault was probably a bad idea. Drilling for oil a half mile west of the reservoir was probably not smart, either.

DECEMBER 15, 1849: WASHED OUT

The first California legislature met in San Jose. Sixteen senators and thirty-six assemblymen planned to attend. Due to heavy rains, the roads were so washed out that only six senators and fourteen assemblymen made it through the challenging weather conditions.

DECEMBER 16, 1896: MAN WITH SYMMETRICAL NAMES

Griffith Griffith, a wealthy mining industrialist, gave 3,015 acres for Griffith Park as a Christmas present to Los Angeles, later adding funds for a Greek theater and an observatory to be named after himself. But his reputation in the community was ruined when he shot his wife with a handgun while she knelt before him. During the 1903 trial, it was revealed that Griffith pretended to be a teetotaler when, in fact, he was a paranoid, delusional drunkard.

Griffith Observatory on the south-facing slope of Mount Hollywood in LA's Griffith Park, Los Angeles, California. Photograph by Carol M. Highsmith (2012). *Courtesy Library of Congress.*

DECEMBER 17, 1846: DONNER PARTY HORROR

Charles Burger and William Murphy, unable to keep up with the snowshoers trying to escape starvation while with the Donner Party, returned to camp. Five women, nine men and twelve-year-old Lemuel Murphy kept going. Patrick Breen wrote in his diary: "Pleasant sunshine today. Wind about S.E. Bill Murphy returned from the mountain party last evening. Bealis died night before last. Milt. & Noah went to Donners 8 days since; not returned yet; thinks they got lost in the snow. J Denton here to day."

DECEMBER 18, 1999: TREE-SITTER DESCENDS

Julia "Butterfly" Hill climbed down from an ancient redwood in Humboldt County after living there for two years. Her protest against logging old-growth redwood forests inspired activists in Berkeley, who also camped in threatened trees on the UC campus for two years.

DECEMBER 19, 1964: CHRISTMAS FLOOD

Heavy rain from December 18, 1964, to January 7, 1965, flooded nearly every river in coastal Northern California. More than twenty-two inches of rain fell on the Eel River basin in just two days. Nineteen people died. At least ten towns were heavily damaged or destroyed, and more than twenty major highway and county bridges flooded. Some four thousand head of livestock drowned in Humboldt County. Called the "Christmas Flood," it was the worst in recorded history on nearly every major stream and river in coastal Northern California. It affected parts of Oregon, Washington, Idaho and Nevada. The event was declared a one-hundred-year storm.

DECEMBER 20, 1955: HOLIDAY DISASTER

Following ten to thirteen inches of rain over three days, rivers flooded throughout the Central Sierras and the south San Francisco Bay Area, killing some fifty people and causing more than $15 million in property damage. A Feather River levee collapsed on Christmas Eve, flooding Yuba City and surrounding farmland. Along the Truckee River, nearly every bridge upstream from Reno was heavily damaged or destroyed. It was declared a one-hundred-year storm.

DECEMBER 21, 1946: TRADITION BEGINS

Frank Capra's *It's a Wonderful Life* premiered. The Christmas fantasy-comedy-drama, filmed in and around Los Angeles, starred James Stewart and Donna Reed. It became among the first holiday classics, along with *Miracle on 34th Street* (1947). But the first Christmas movie—among the very first movies of any kind—was *Santa Claus* (1898) by George Albert Smith, a British pioneer of filmmaking.

DECEMBER 22, 1847: ORCHARD ARRIVES

John Sutter received a shipment of two thousand fruit trees, which began Sacramento Valley's agriculture industry. The type of trees and their origin are not known. Agricultural output in Sacramento County in 2014 was valued at $495,403,000, notably in rice, wine grapes and tomatoes. California produces one-third of all U.S. vegetables and two-thirds of the country's fruits and nuts.

Sutter's Fort, 1849. Lithograph by George Victor Cooper (circa 1852). *Courtesy Library of Congress*.

DECEMBER 23, 1941: JAPAN ATTACKS

Fifteen days after the Japanese attacked U.S. forces at Pearl Harbor, Hawaii, a Japanese submarine torpedoed and sank the Union Oil tanker *Montebello* off the coast of Cambria. The largest oil tanker in the world, it was carrying three million gallons of crude oil. Luckily for the sailors, the broadside attack struck the only compartment not loaded with gasoline. Also luckily for the thirty-eight sailors, no one was wounded as they lowered lifeboats and pulled for shore while the Japanese fired on them. The U.S. Navy officially denied the attack.

DECEMBER 24, 1914: DEATH OF A NATURALIST

John Muir, Scottish-born American naturalist and Sierra Club founder, died in Los Angeles at age seventy-six. He expressed his passion for the natural world after landing in San Francisco in 1868, asking for directions to Yosemite, then setting off to walk the 310 miles to get there.

DECEMBER 25, 1978: ART THIEVES STRIKE

Four Renaissance paintings were stolen from the De Young Museum in San Francisco. Three works, including Rembrandt's *Portrait of a Rabbi*, were recovered in New York City in 1999. One is still missing.

Art in Golden Gate Park in front of the De Young Museum, San Francisco, California. Photograph by Carol M. Highsmith (2012). *Courtesy Library of Congress.*

DECEMBER 26, 1978: PIZZA + VIDEO GAMES

Nolan Bushnell, inventor of the Pong video game, opened the twenty-thousand-square-foot Pizza Time Theater in San Jose, then the world's largest pizza parlor. He introduced Pong at Andy Capp's Tavern in nearby Sunnyvale on November 29, 1972. Now rebranded as Chuck E. Cheese's, Pizza Time Theater has grown into a chain of family entertainment restaurants.

DECEMBER 27, 1961: MYTHIC SONG

Tony Bennett, appearing at the Fairmont Hotel's Venetian Room in San Francisco, sang his first solo rendition of "I Left My Heart in San Francisco." Written in Brooklyn, the song that nostalgically portrays one's regret of leaving San Francisco has become identified as Bennett's—and the city's—signature song. A statue of a singing Bennett was unveiled outside the Fairmont Hotel in 2016.

DECEMBER 28, 1999: GOODBYE MASKED MAN

Clayton Moore, star of *The Lone Ranger* television series in the 1950s, died in Calabasas at age eighty-five. The show started as a 1930s radio series about a heroic mysterious former Texas Ranger before it became the first Western written for TV. The show's popularity grew to the point that, after it ended, Moore enjoyed forty years of personal appearances, TV guest spots and commercial endorsements as the Lone Ranger.

DECEMBER 29, 1856: SNOW IN SAN FRANCISCO

Snow fell in San Francisco and accumulated to two to three inches. Snowfalls have been recorded in a dozen years since 1856, but the snowiest decade was the 1880s, when snow fell in 1882, 1884, 1887 and 1888. Up to seven inches was measured on Twin Peaks in 1887, and up to five inches fell there on February 5, 1976.

DECEMBER 30, 1940: FIRST FREEWAY

A section of Arroyo Seco Parkway, essentially California's first freeway, opened in Los Angeles just in time for the Tournament of Roses Parade and the Rose Bowl. The first section ran from Avenue 40 to the Figueroa Street Viaduct at Avenue 22, following the path not only of a dry creek bed but also of the California Cycleway Company's six-mile elevated wooden bicycle tollway linking LA to Pasadena.

DECEMBER 31, 1961: MUSICAL COINCIDENCE

Brothers Brian, Carl and Dennis Wilson, their cousin Mike Love and a friend, Al Jardine, performed for the first time as the Beach Boys. On December 31, 1978, the Grateful Dead's performance for the last concert at San Francisco's Winterland Arena, famous for its legendary rock 'n' roll shows, turned into a five-hour party.

Bibliography

BOOKS

Culbertson, Judi. *Permanent Californians: An Illustrated Guide to the Cemeteries of California*. White River Junction, VT: Chelsea Green Publishing Company, 1989.

Eargle, Dolan. *The Earth Is Our Mother: A Guide to the Indians of California, Their Locales and Historic Sites*. San Francisco, CA: Trees Company Press, 1991.

Fradkin, Philip. *The Seven States of California: A Natural and Human History*. Berkeley: University of California Press, 1995.

Gudde, Erwin. *California Place Names: The Origin and Etymology of Current Geographical Names*. 4th ed., revised and enlarged. Berkeley: University of California Press, 2010.

Hanna, Phil Townsend, and Herbert Eugene Bolton. *California Through Four Centuries: A Handbook of Memorable Historical Dates*. New York: Farrar & Rinehart, 1935.

Kyle, Douglas, et al. *Historic Spots in California*. 5th ed. Stanford, CA: Stanford University Press, 2002.

Rolle, Andrew, and Arthur C. Verge. *California: A History*. 8th ed. Hoboken, NJ: Wiley-Blackwell, 2014.

Starr, Kevin. *California: A History*. New York: Modern Library Chronicles, 2007.

Bibliography

WEBSITES

This Day in History. http://www.history.com/this-day-in-history.

Timelines of History. http://timelines.ws.

Wikipedia: WikiProject Days of the Year. https://en.wikipedia.org/wiki/Wikipedia:WikiProject_Days_of_the_year.

About the Author

Jim Silverman, retired librarian and authority on early California children's books, curates http://ThisWeekinCaliforniaHistory.com, which he envisions as a digital playground for practicing the skills of historians and geographers. Follow him on Facebook.